Nic Nicosia

Real Pictures 1979–1999

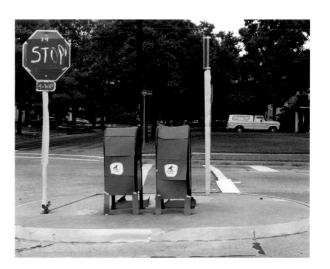

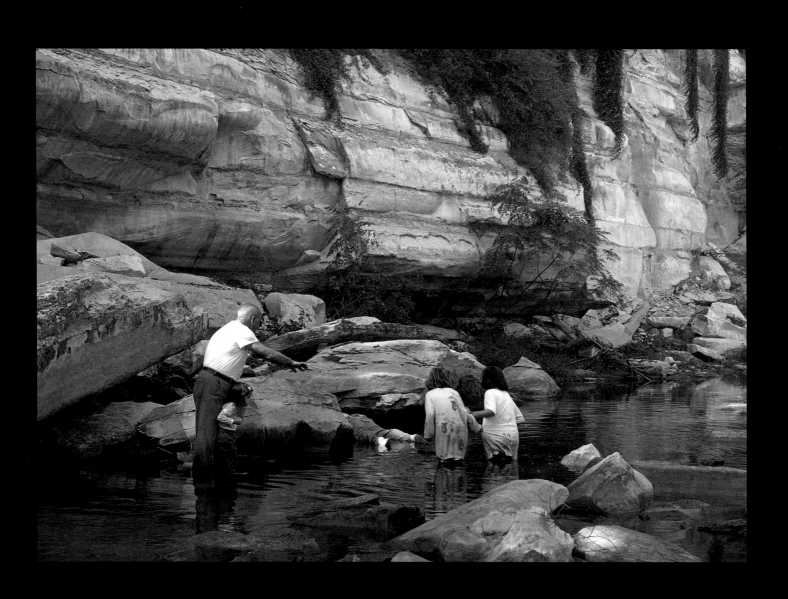

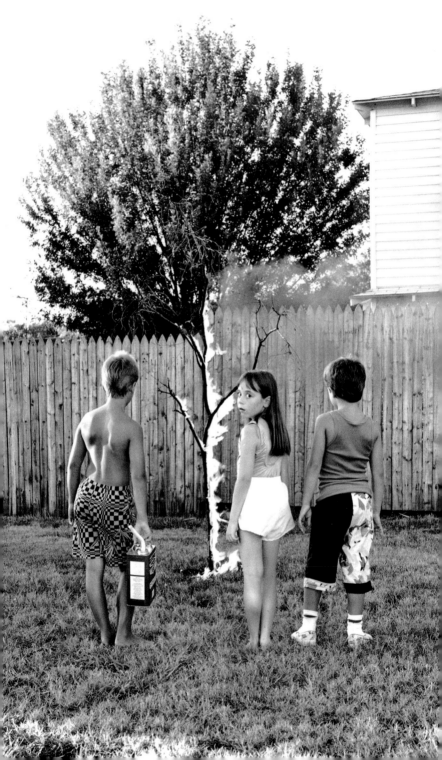

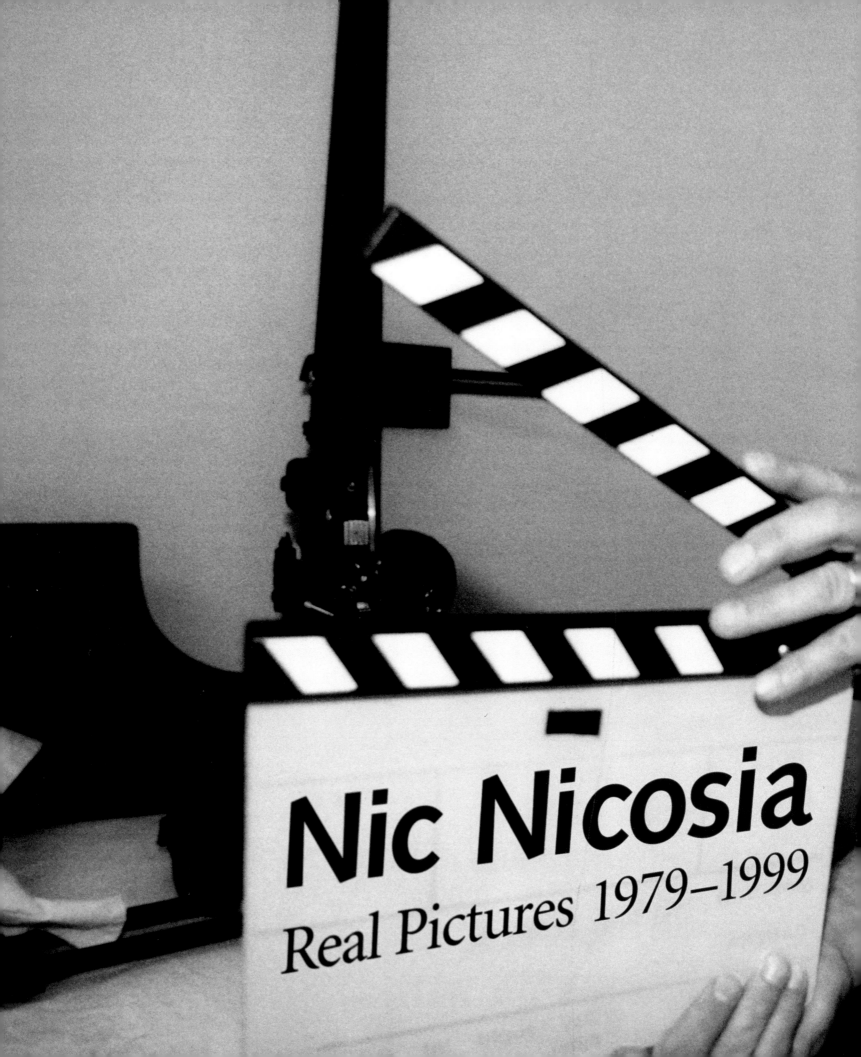

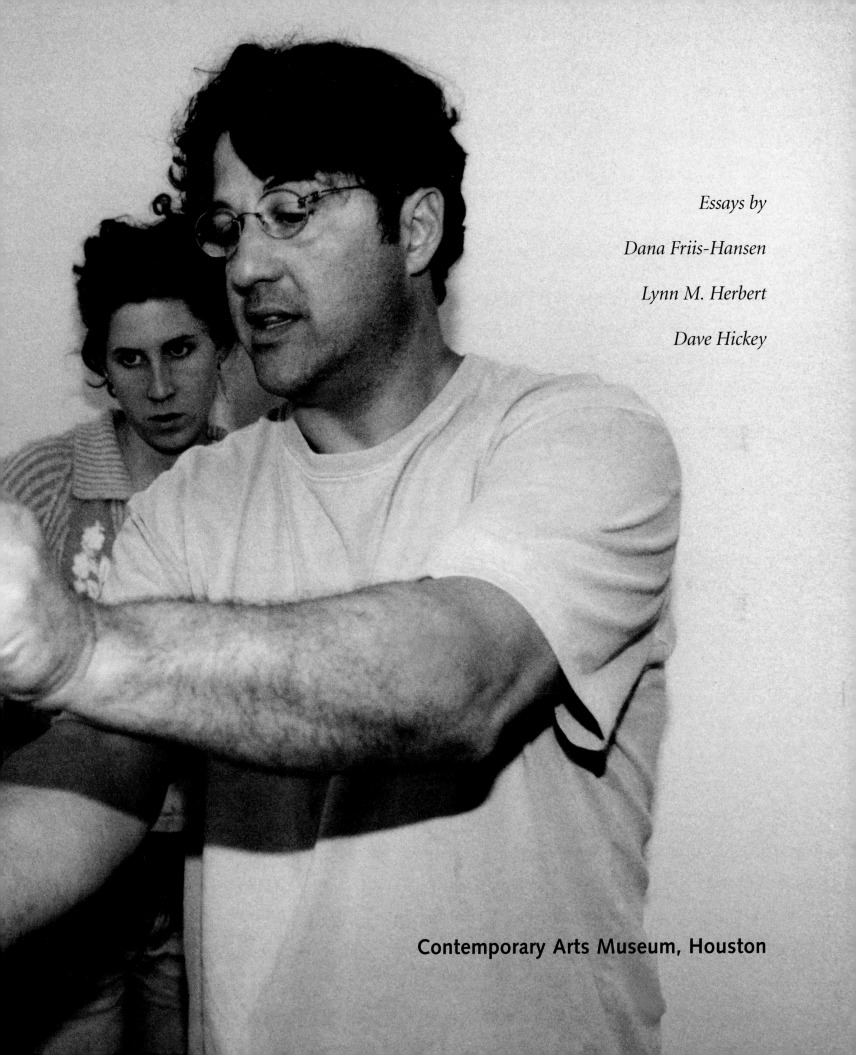

Essays by

Dana Friis-Hansen

Lynn M. Herbert

Dave Hickey

Contemporary Arts Museum, Houston

This catalogue has been published to accompany the exhibition
Nic Nicosia: Real Pictures 1979–1999
organized by Dana Friis-Hansen, Senior Curator,
and Lynn M. Herbert, Curator
Contemporary Arts Museum, Houston

Exhibition Itinerary
Contemporary Arts Museum, Houston
September 25 – November 28, 1999

Dallas Museum of Art
May 25 – August 27, 2000

Nic Nicosia: Real Pictures 1979–1999 has been made possible by the
Contemporary Arts Museum's Major Exhibition Fund contributors:

Major Patron
Fayez Sarofim & Co.

Patron
Mr. and Mrs. A.L. Ballard
George and Mary Josephine
 Hamman Foundation
Mr. and Mrs. I.H. Kempner III
Ms. Louisa Stude Sarofim

Benefactors
Max and Isabell Smith Herzstein
Rob and Louise Jamail
Mary Lawrence Porter
Mr. and Mrs. Marvin H. Seline
The Susan Vaughan Foundation

Donors
American General
Dr. and Mrs. Bernard Arocha
Arthur Andersen LLP
Baker & Botts L.L.P.
Mary Lynch Kurtz
Shell Oil Company Foundation
Stephen D. Susman
Herbert Wells
Mr. and Mrs. Wallace S. Wilson

The exhibition catalogue has been supported by
The Brown Foundation, Inc.

cover: Still from *Middletown Morning* (detail), 1999, 16mm film.
 Courtesy the artist, Dunn & Brown Contemporary, Dallas;
 P•P•O•W, New York; and Texas Gallery, Houston
back cover: *Untitled #7*, 1992, silver gelatin photograph with oil
 tint, 36 x 36 inches. Collection of the Modern Art Museum of
 Fort Worth, Museum Purchase, made possible by a grant from
 The Burnett Foundation.
p. 1: *Mail Boxes*, 1980, chromogenic photograph, 20 x 30 inches.
 Courtesy the artist, Dunn & Brown Contemporary, Dallas;
 P•P•O•W, New York; and Texas Gallery, Houston
p. 2: *Real Pictures #6*, 1987, silver gelatin photograph, 48 x 68
 inches. Collection Marguerite and Robert Hoffman, Dallas
p. 3: *Real Pictures #11*, 1988, silver gelatin photograph, 79 x 48
 inches. Collection The Museum of Modern Art, New York:
 E.T. Harmax Foundation Fund
pp. 4–5: Nic Nicosia on the set of *Middletown Morning* with
 co-cinematographer, Megan Flax, 1999

Library of Congress Catalogue Card Number 99-074525
ISBN 0-936080-53-1

Distributed by:
Distributed Art Publishers (D. A. P.)
155 Sixth Avenue
New York, New York 10013
212-627-1999

Contemporary Arts Museum, Houston
5216 Montrose Boulevard
Houston, Texas 77006-6598
phone: 713-284-8250; fax: 713-284-8275
www.camh.org

Contents

9 Lenders to the Exhibition

Marti Mayo **10** Foreword and Acknowledgments

Lynn M. Herbert **13** **The Suburban Subconscious: *Et in Arcadia Ego***

 24 **Plates:** Early Works, 1979–81

 "Domestic Dramas," 1982

 "Near (modern) Disasters," 1983

 "The Cast," 1985

 "Life As We Know It," 1986

Dana Friis-Hansen **45** **Close to Home**

 52 **Plates:** "Real Pictures," 1987–89

 "Love + Lust," 1990–91

 "Untitled," 1991–93

 "Acts 1–9," 1994–95

Dave Hickey **77** **Nic Nicosia in Picture World**

 80 **Plates:** Film and Video, 1997–99

 93 Catalogue of the Exhibition

 95 Film and Video Credits

 96 Biography

 100 Bibliography

Lenders to the Exhibition

Deborah Brochstein, Houston

Lisa and Charles Brown, Dallas

Mr. and Mrs. Sanford W. Criner, Jr., Houston

Dallas Museum of Art

Dunn & Brown Contemporary, Dallas

Frito-Lay Inc., Plano, Texas

Gerald Peters Gallery, Dallas

Solomon R. Guggenheim Museum, New York

Harry Ransom Humanities Research Center,
 The University of Texas at Austin

Marguerite and Robert Hoffman, Dallas

Fredericka Hunter and Ian Glennie, Houston

John and Susie Kalil, Houston

Jeanne and Michael Klein, Houston

William Lincoln, Fort Worth

Modern Art Museum of Fort Worth

The Museum of Modern Art, New York

New Orleans Museum of Art

Nic Nicosia

Eileen and Peter Norton, Santa Monica

P•P•O•W, New York

Private Collection

Private Collection, Houston

Cece Smith and John Ford Lacy, Dallas

Debra Stevens, Dallas

Mr. and Mrs. Stephen Susman, Houston

Texas Gallery, Houston

opposite: Still from *Middletown Morning* (detail), 1999, 16mm film. Courtesy the artist,
Dunn & Brown Contemporary, Dallas; P•P•O•W, New York; and Texas Gallery, Houston

Foreword and Acknowledgments

The Contemporary Arts Museum presented its first photography exhibition fifty years ago. Organized by the American Federation of Arts, New York, *L. Moholy-Nagy: Memorial Exhibition* was on view from October 15 to November 10, 1949.

Photography and the Museum have both come a long way since. Now accepted without question as one of the important media of the twentieth century, photography has played an increasingly pivotal role in art since the late 1970s when it morphed from an important media in and of itself into a tool in the development of work in other media—painting, sculpture, and graphics. In 1981, as the Museum's curator, I wrote in an introduction to *The New Photography*, the ninth exhibition in the Museum's now long-running *Perspectives* series:

> "Increasingly in the past few years, a number of young artists have chosen the photographic medium as a vehicle for their ideas . . . many of these artists are not interested in carrying forth the traditions established by the generations of photographers which preceded them; some are not even interested in being 'photographers,' per se. They are not as concerned with fine art photography as they are with making a work of art using the camera as the tool and film as their medium."*

Nic Nicosia was one of the twelve photographers presented in *The New Photography*; he was thirty and had recently moved to Houston from Denton, Texas, to try out graduate school. Nicosia had called the Museum and made an appointment to show his work to the staff. We were immediately taken with it and recognized that it was part of a national and international move toward the use of the medium to ends other than a document made evident in the perfect print. Rather, his work—the early photographs of collaged sites—was a surreal statement about the gestalt of seemingly ordinary scenes of our lives and those of our neighbors.

Over the ensuing years, Nicosia's work has been shown in two other group exhibitions at the Museum: *Southern Fictions* (1983) and ten years later in *Texas/Between Two Worlds* (1993). Over the same years, his photographs began to be shown extensively at prestigious venues within Texas, across the U.S., and in Europe; by the late 1980s, they had earned him serious recognition. Houston audiences have been especially fortunate to have the opportunity to follow the course of his work through several series and to observe its metamorphosis from the playful character of

the 1980s to the more moving and troubled photographs that characterize his oeuvre in the 1990s. In a way, however, this regularity—the experience of seeing the work in succession and in series—has prevented us from considering it as a whole, from discovering its broader themes and overall depth.

Nic Nicosia: Real Pictures 1979–1999 is the first survey exhibition of the artist's work and as such provides us the opportunity to consider his full career. We believe it will surprise many of us as it will allow an assessment of the full breadth and scope of some twenty years of work by this most energetic and provocative of Texas artists.

Real Pictures has been curated by Senior Curator Dana Friis-Hansen and Curator Lynn M. Herbert, and both have contributed insightful essays to this catalogue that draw on their own particular strengths. Friis-Hansen has written from a conceptual view illuminated by his interests in the individual within a culture; Herbert has commented from a long and scholarly acquaintance with photography and its history, as well as from her own insight regarding Nicosia's background and viewpoint. We are grateful to both for their expertise and passion. Both curators would like to express their gratitude to Fredericka Hunter and Ian Glennie of Texas Gallery, Houston—Nicosia's longtime representative in this region. They have been unstinting in their assistance to the project and especially generous in sharing their knowledge about the artist and his work. Sue Graze, executive director of Texas Fine Arts Association, has graciously added her own longtime knowledge of Nicosia's work to the curators' efforts.

Dave Hickey, Professor of Art Criticism and Theory, University of Nevada, Las Vegas, critic extraordinaire, and Nicosia's collaborator on the series "Life As We Know It," has enriched the publication with a provocative essay placing Nicosia's work in the context of a broad spectrum of Western art history.

Lisa Brown and Talley Dunn of Dunn & Brown Contemporary, Dallas; Wendy Osloff and Penny Pilkington of P·P·O·W Gallery, New York; and again Ian Glennie and Fredericka Hunter of Texas Gallery, Houston, have provided invaluable assistance to the project at every stage of its organization, and we are indebted to

them for their good cheer, assistance above and beyond the call, and for their many courtesies.

We are especially grateful to those individuals and organizations who have loaned work to the exhibition. Listed on page 9, the lenders have shown great spirit and generosity by sharing their valuable and valued works of art with us all.

Nic Nicosia: Real Pictures 1979–1999 is supported by the individuals, foundations, and corporations who have contributed to the Museum's *Major Exhibition Fund* (page 6). During 1999, many of our most loyal contributors to the Fund recognized and acknowledged the need for increased support for the most fundamental component of our mission: the exhibition of important contemporary art to audiences in Houston and beyond. These generous individuals, foundations, and corporations responded by increasing their level of support—many quite significantly. We deeply appreciate the generosity of all Fund contributors, especially *Major Patron* Fayez Sarofim & Co., and *Patrons* Mr. and Mrs. A.L. Ballard, the George and Mary Josephine Hamman Foundation, Mr. and Mrs. I.H. Kempner, and Ms. Louisa Stude Sarofim.

This publication, as will be the case for all catalogues published by the Museum through 2002, is supported by a very generous grant from The Brown Foundation, Inc. The Contemporary Arts Museum's Board of Trustees and its audiences are most grateful for this enlightened support, which enables the Museum to both fulfill the scholarly part of its mission and at the same time to provide audiences in Houston and beyond a resource that will remain long after the exhibition has closed.

Our enthusiasm for Nicosia's work is shared by our colleagues at the Dallas Museum of Art, and the exhibition will travel there in the summer of 2000. We are grateful for the commitment of Director Jack Lane, Lupe Murchison Curator of Contemporary Art Charles Wylie, and Assistant Curator Suzanne Weaver.

In a small (but innovative and entrepreneurial) institution like the Contemporary Arts Museum, each member of the staff plays an important role in major projects like *Nic Nicosia: Real Pictures 1979–1999.* The exhibition curators especially wish to thank Paola Morsiani, assistant curator, for her consistent and unwavering dedication to excellence and to detail; her assistance has been invaluable. This project also benefited from the curatorial assistance of three interns: Elizabeth Compton, Southeastern Louisiana University; Jocelyn Hu, Smith College; and Janaki Lennie, University of Houston. Tim Barkley, registrar, oversaw the loans and their transport and installation. Peter Hannon, preparator, supervised the crew and installed the exhibition with care and attention. Kelli Dunning, director of public relations and marketing, and her assistant, Wesley Miller, a summer employee from Sarah Lawrence College, assured that the Museum's audiences were informed about the exhibition. Meredith Wilson, director of education and public programs; Paula Newton, education assistant, and Claire Chauvin, web coordinator, organized and executed the education events surrounding the show. Karen Skaer Soh, director of development, and her staff oversaw the acquisition of needed resources and organized the opening events. Michael Reed, assistant director, helps everyone, all the time, and is pivotal to our efforts.

This handsome catalogue has been designed by Don Quaintance of Public Address Design, an award-winning firm specializing in art books and related materials. Quaintance was ably assisted by Elizabeth Frizzell.

Chris Corlae, Amy Owen, Brooke Nicosia, and Katey Nicosia, assistants to the artist, provided him invaluable support, and he wishes to thank them for their help with this project.

Finally, and of course, our gratitude must go to the artist. Many of us at the Museum have known his work for a long time and all of us are very proud to present his first museum survey exhibition. Nicosia is recognized worldwide as an important artist and an extremely thoughtful and provocative photographer. But he never forgets to be kind while being thorough, never forgets to have fun while maintaining serious and exacting professional standards. The rewards of organizing this project have resided in the brilliance of Nicosia's work, but much of the joy is due to the artist himself.

Marti Mayo
Director

* Linda L. Cathcart and Marti Mayo, *The New Photography* (Houston: Contemporary Arts Museum, 1981), unpaginated.

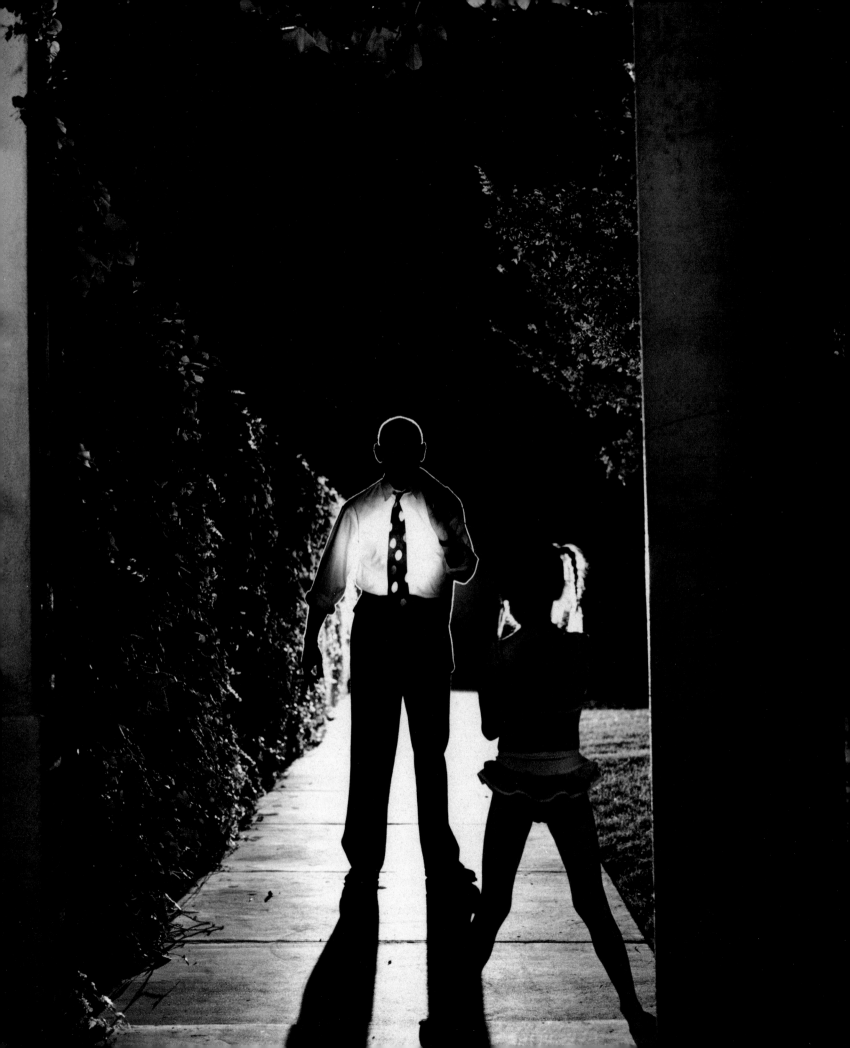

The Suburban Subconscious: *Et in Arcadia Ego*

Lynn M. Herbert

In many respects, Nic Nicosia's photographs, films, and videos of the last twenty years are a reflection of the 1980s and 1990s, two decades that have seen art enter endless new territories. His works embody the revolutionary changes that were taking place in the history of photography. They illustrate technological advances that made larger and bolder gestures possible. And they allude to the growing power of the mass media upon all of our lives and to the wave of postmodernism that dominated the arts during this time.

And yet, at many turns, Nicosia chose to step off this heady bandwagon. His subject of choice is "life in the heartland," hardly a cultural focal point or topic demanding the public's attention. And during an era when much contemporary art-making dwelled upon philosophical, intellectual, or political conceits, Nicosia allowed his work to flow from his subconscious pretty much unmediated by theoretical spin.

If one were seeking the "American dream," a logical first place to look would be in a middle-class suburb in America's heartland. Nicosia's "suburb," however, is full of unseemly truths rooted in lust, perversion, random violence, rage, and death. He presents these topics in formats that draw upon familiar conventions of cartoons, television, and film, thereby making them seductively accessible. His innate sense of humor then pulls us in even further.

This exhibition examines works made by Nicosia during the past twenty years. In the individual series of photographs and the more recent films and videos, one can follow the evolution in Nicosia's work from unabashedly playful to introspective, from slapstick to "noir," from stills to films. This survey also allows viewers to discover and enjoy the array of themes and the recurring troupe of characters that weave in and out of Nicosia's works. In these still and moving pictures, Nicosia has created fictions that depict the underlying reality of life in suburbia. They delve into the suburban subconscious and reveal what Nicholas Poussin's Arcadian shepherds discovered long ago: *Et in Arcadia Ego* (fig. 2).[1] Even in the best of worlds there is darkness.

In the late 1970s, when Nicosia began to make photographs, the field of photography was going through a revolution of sorts: truth was giving way to what came to be called "the directorial mode."[2] For years, leaders in photography had extolled the virtues of the straight, uncropped print. So adamant was their stance that this belief took on the weight of a moral imperative. For photographers such as Ansel Adams and members of Group f/64, the "medium of truth" was meant to deliver the truth. Over time, however, the tables turned. More and more photographic practitioners began to manipulate, stage, and alter their photographs, using the photograph's appearance of objective honesty against the viewer—effectively loading their works with "injected" truths.

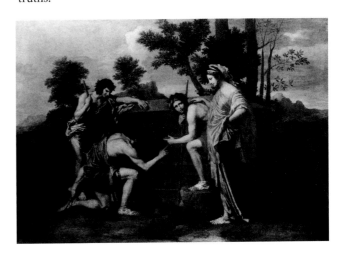

fig. 1 Nic Nicosia, *Untitled #9* (detail), 1992, silver gelatin photograph with oil tint. Collection of the Modern Art Museum of Fort Worth, Museum Purchase, made possible by a grant from The Burnett Foundation

fig. 2 Nicolas Poussin (1594–1665), *Et in Arcadia Ego* (The Shepherds in Arcadia), Post-restoration, oil on canvas, 33½ x 47⅝ inches. Louvre, Paris

While this movement seemed revolutionary at the time, historically speaking, it was anything but. Artists had staged scenes for the camera ever since the invention of photography. The two photographers whose works first illustrated to a large audience this potential within the medium were the Swede Oscar G. Rejlander and the Englishman Henry Peach Robinson. Interestingly enough, both men created work that speaks to Nicosia's both in style and content.

Rejlander's tour de force was *The Two Ways of Life* (1857), a photograph in which a wise sage lays before a youth the two branching paths of life, that of virtue and that of vice. Rejlander used a troupe of actors and printed from thirty negatives onto one sheet of paper to create this image, a technique that was called "combination printing."[3] Other photographs, such as *The Dream* (ca. 1860, fig. 3), show Rejlander venturing into a more surreal realm. Here he has jumped from the grand tradition of historical painting into the quieter, more personal domain of genre painting. The gentleman on the chaise appears to be experiencing an angst-driven nightmare, possibly Rejlander's own.

Robinson, who continued Rejlander's practice of combination printing, is best known for *Fading Away* (ca. 1880, fig. 4). Here lies a young girl in the bloom of life, "fading away" before our very eyes. Robinson made her impending death all the more tragic by surrounding her with women representing the other stages of life that she now will never attain. He then added a touch of mystery with the intrusive, silhouetted male figure standing with his back to us, staring out the window where even the heavens seem distraught.

Many other artists were to follow Rejlander and Robinson's lead. Julia Margaret Cameron and Hill & Adamson were other nineteenth-century practitioners in this mode. The early twentieth century saw the flourishing of the Pictorial movement, which featured the "staged" works of Clarence White, F. Holland Day, and Gertrude Kasebier. And even during the years when the purists took the helm, photographers such as Jerry Uelsmann,

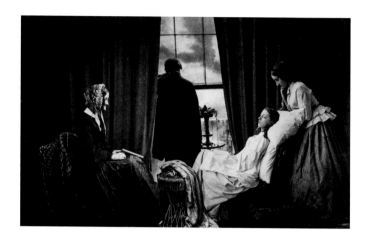

Duane Michals, and Les Krims continued to pursue their own form of "photographic truth."

The late 1970s and early 1980s turned out to be breakaway years for photography. As the purist argument slowly became irrelevant, staged realities began to appear in all shapes and sizes. Museums were caught off guard, physically as well as conceptually. They couldn't figure out which department these works belonged in. They were too big for any of the standard archival storage boxes, so sheer size sent them into many a painting department before the photography departments found a way to accommodate them. What was one to do with the likes of Barbara Kruger's new form of print, made from a photographic negative to be as big as a painting? It was like a heady stampede. Conceptual artists such as John Baldessari, Robert Cumming, Bruce Nauman, John Pfahl, Ed Ruscha, Cindy Sherman, and William Wegman embraced photography's implied truth. Many were directly challenging the media culture in their work, and the media responded by showering this new work with attention. The world was opening up and no one wanted to be called a "photographer" anymore. That label was set aside in favor of the more inclusive "artist."[4] It was during these riveting years that Nic Nicosia's work first emerged.

Nicosia was born in Dallas in 1951, the second of four children. His father was a dentist and his mother was an artist. His childhood was spent in Dallas where in high school he began to make films using a Super-8 camera. He remembers them as "guy stuff": a car crash, a Western with a hanging, and a skiing film.[5] He loved making the films, but for the time being, he put off the idea of pursuing it further. After high school, he went to the University of North Texas in Denton, located just outside of Dallas. During his first years there, he dabbled in psychology and business, and like most young men his age, he worried about the draft. In his third year, he tried some

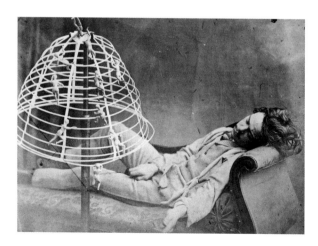

fig. 3 O.G. Rejlander, *The Dream*, ca. 1860, albumen print. Courtesy George Eastman House, Rochester, New York

fig. 4 H.P. Robinson, *Fading Away*, ca. 1880, albumen print. Courtesy George Eastman House, Rochester, New York

classes in the radio/TV/film department and found that cinematography came naturally to him. He was good at it and ended up majoring in communications. Upon graduating, Nicosia opened up a photography supplies store in Denton and got married.

Nicosia ran the store from 1974 to 1979 and it was there that he first learned about photography by chatting with the customers, particularly the photojournalists. He began to wander the streets trying out a kind of Lee Friedlander/Garry Winogrand street photography. Though he didn't feel as if he was getting anything, that was the moment in his life when he realized that he wanted to be an artist. He began to take graduate courses at the University of North Texas and discovered for the first time the revolution that was taking place in the realm of photography. Van Deren Coke's exhibition *Fabricated to Be Photographed* (1979), organized for the San Francisco Museum of Modern Art, was particularly exciting to him.[6] Nicosia immersed himself in art history (it had not been a part of his communications curriculum) and set out to catch up with his fellow graduate students. After graduate studies at the University of North Texas and the University of Houston, he began to make art feverishly. He also moved back to Dallas and the middle-class suburbs that would prove to be his enduring muse.

Dallas is a conservative community in the heartland. It is the city that brought us television's infamous J.R. Ewing and on whose streets President Kennedy was assassinated. It is a community long on economic possibilities and short on cultural diversity. Nicosia grew up with television programs like *Leave It To Beaver* and *Father Knows Best* that portrayed idealized family life in neighborhoods like his own. But Nicosia found himself more interested in what lurked underneath that conservatism, the darker realities explored in more recent programs like *Twin Peaks* and the 1998 films *The Truman Show* and *Pleasantville.*

Nicosia began by creating a series of urban interventions using a variety of techniques; Susan Sontag's ground-breaking book *On Photography* was an inspiration for these early works.[7] Nicosia had always thought that photographs lied and he was interested in blurring reality, bringing fact and fantasy together in one work. This exhibition begins with *Untitled* (1979, fig. 22), which Nicosia created by drawing and collaging on a photograph of a house and then rephotographing his altered work. In *Cityscape #1* (1980, fig. 5), he photographed a Friedlander-like street corner, replete with a cacophony of signs, shapes, and angles, and covered it with collage elements that seem to dance over the surface of the image, giving it the look of a still lifted from an animated short.

Whereas Friedlander was recording single photographic moments in time with a camera that brought together an amazing array of images, Robert Rauschenberg put no such limits upon himself, bringing together in his work assorted elements from all

kinds of sources using all kinds of materials. Nicosia found this latter approach liberating and left the studio to apply collage on site and then photograph his efforts. John Pfahl, who had begun creating "elegant visual puns" in the landscape with tape, rope, foil, and other props, was another influence and Nicosia's *River* (1981) is a more humorous, rough-and-tumble version of Pfahl's trompe l'oeil illusions.[8] Nicosia found that he enjoyed taking on multiple roles (in these works he served as designer, fabricator, and photographer), and he went on to "collage" a convenience store (*Pay-Per Phones*, 1980, pl. 2), a street corner (*Mail Boxes*, 1980, page 1), and the facade of a building (*Vacant*, 1980–81).

As he learned more about art history, Nicosia developed an appreciation for the "look" of Pop Art. By this time, he had two daughters, and one day he picked up one of their coloring books. He was drawn to the cartoonish flattened space, similar to what he had seen in Pop Art, and he began to toy with perspective in his own works. In *Coloring Book, page 2* (1981, fig. 25), however, a work dominated by a stylized, patently false interior, Nicosia for the first time added a human presence.

Nicosia followed these early works with a distinct series entitled "Domestic Dramas." As the title suggests, these works depict life at home. Nicosia built sets from scratch in his studio and called upon the services of friends and family to recreate scenes illustrating the strains of domestic life. In these works, children draw on walls and spill paint on the floor; a couple argues about the plans for their dream house; and a husband and wife each find erotic temptations alternately in the workplace and the home (fig. 27, pls. 4–6). Dolls, or "handy actors" as Nicosia refers to them,[9] are scattered about on the floors, making their debut as symbolic characters that would appear again and again in Nicosia's work.

In these large-scale color photographs, Nicosia's actors inhabit garishly colorful cartoonlike sets. Such blatant artifice represented a new direction for many artists engaged in creating photographic tableaux at the time. Sandy Skoglund is another

fig. 5 Nic Nicosia, *Cityscape #1*, 1980, chromogenic photograph, 24 x 36 inches. Courtesy the artist, Dunn & Brown Contemporary, Dallas; P·P·O·W, New York; and Texas Gallery, Houston

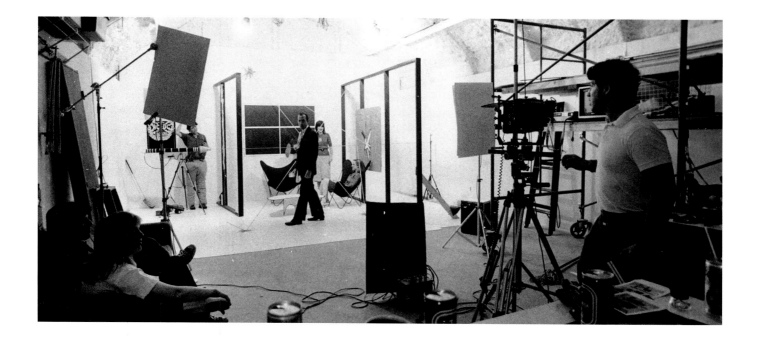

artist who, like Nicosia, was exploring the inner life of middle-class America by creating tableaux from scratch and photographing them. Skoglund, however, created scenes depicting apocalyptic nightmares, while Nicosia stayed within the realities of the everyday anxieties plaguing domestic life.

Nicosia next embarked on a series of photographs that addressed the range of random disasters, large and small, that he saw taking place all around him. In *Near (modern) Disaster #8* (1983, pl. 7), a father desperately holds onto his daughter who is about to be blown away by hurricane winds, while a woman holds onto a "no parking" sign for dear life even as beach chairs and umbrellas around her are blowing out to sea. Nicosia allowed all of the artifice to show in the photograph, including the rigging that suspended the young girl in midair. *Near (modern) Disaster #7* (1983, pl. 8) perfectly demonstrates Robinson's formula for a successful pictorial tableau photograph: "variety of pose, age, and attitude of figure types unified through pyramidal massing and chiaroscuro."[10] This frantic, boffo work is full of stock exaggerated gestures, complete with a Pop exclamation, "Yeeeowww!" Nicosia threw in some tanks and barbed wire for good measure, alluding to the plethora of small wars that were breaking out around the world at the time. In *Near (modern) Disaster #2* (1983, pl. 9), a laser beam crisscrosses a stylish interior, terrorizing its inhabitants and piercing a modernist painting (fig. 6). The figure in the left corner who appears to have triggered this melée may be a stand-in for Nicosia himself, a die-hard gadget and technology fanatic. In the upper corners, one can also see signs of a larger reality in the form of Nicosia's studio insulation. Just what it all means is left up to the viewer.

In 1985, Nicosia shifted gears a bit, setting himself a new challenge. He began to play with stereotypes, going beyond his circle of friends and family to look for strangers he could "cast" in certain roles. He wanted more character development than he felt he had achieved in earlier works, and in "The Cast" series he expanded his directing skills by relying less on exaggerated gestures and sets and more on facial expression, makeup, and costuming. Also for the first time in Nicosia's work, the "star" makes direct eye contact with the viewer. In *Bill and Pete* (1985, pl. 10), Nicosia portrayed suburban "white trash" in a backyard, drinking and smoking while one waters the lawn wearing a pistol and combat gear. Pete is giving us the "You talkin' to me?" stance that Robert de Niro immortalized in Martin Scorsese's film *Taxi Driver* (1976). In *Ms. D'Avignon* (1985, pl. 12), we have an aging starlet who is fighting time, surrounded by furniture that mirrors her crumbling beauty. *Tristano* (1985, pl. 11) brings center-stage the exhausted stagehand who so often goes unnoticed.

In retrospect, Nicosia feels that these were probably his first portraits.[11] They required a more sophisticated kind of directing, and Nicosia found himself trying out Woody Allen's method of giving his actors license to run with ideas themselves. At the time, Nicosia described these characters as "the kinds of people we're always making fun of to a certain extent. It's about the fact that we often base our judgment of a person on first impressions. . . . I'm trying to give these people a certain amount of dignity."[12] When asked what was coming next, he replied, "It will still be fantasy, rather than reality, but people will always be more important to me after 'The Cast.'"[13]

Nicosia's next series, "Life As We Know It," was made during a

fig. 6 Nic Nicosia's studio while making *Near (modern) Disaster #2*, 1982

time haunted by new contemporary forms of violence. Planes were crashing, terrorists were bombing department stores, the space shuttle exploded just after takeoff, and Nicosia began to feel that even his own family's isolated world was no longer a safe haven. In *Violence* (1986, pl. 15), the smart set has gathered for a cocktail party when all of a sudden, in the midst of all of this civilized chardonnay-sipping, one "suit" punches another in the stomach. Most of the guests reservedly frown upon this sudden outburst, while another in the extreme foreground smiles at us in a vain effort to pretend that nothing is wrong. Nicosia was tired of being asked, "Which part did you fabricate?" or "What part did you paint?" With this series, he consciously tried to steer the viewers' attention toward content.

Nicosia also wanted to add another dimension to the work: sound. He first thought of adding sound effects, but then decided to collaborate with critic and singer/songwriter Dave Hickey to give these works, in essence, a soundtrack. The title of the series is taken from one of Hickey's songs, the chorus of which goes:

> Life as we know it, deep in the heartland,
> Laden with riches and tortured by dreams.
> Life as we know it, stuck in the heartland.
> Frayed at the edges and torn at the seams.[14]

Hickey was living in Fort Worth at the time, which is only a few miles from Dallas, and as these lyrics indicate, he shared some of Nicosia's sentiments about "life in the heartland." Both men happened to be reading Ann Rice's bestseller, *Interview with a Vampire,* leading Hickey to write "Baby Vampires" while Nic created *Untitled (Sam)* (1986, pl. 13). Set in the prim surroundings of a little girl's birthday party, Sam appears from nowhere to take over the front of the picture plane, monopolizing the focus. With his spiked hair and bloody fangs and nails, he's poised to terrorize the party.

As one critic pointed out,

> There are connections between his [Nicosia's] tableaux and those of artists like Cindy Sherman and Laurie Simmons; but in place of the anxious ambivalence inherent in the work of his East Coast counterparts, Nicosia exhibits an affectionate sympathy for the cliché as well as a broad good-natured humor of the sort that seems to thrive best west of the Hudson.[15]

Nicosia, however, was already on his way to creating images as "dire" as those east of the Hudson. In *Like Photojournalism* (1986, pl. 14), he took his examination of violence up another notch, addressing the havoc terrorism inflicts upon innocent victims. He added an additional dimension to this study by including in the scene a photojournalist who, in the face of such tragedy, still manages to do his job.

At this point in his career, Nicosia was actually more in sync with Canadian artist Jeff Wall, who was also creating photographic tableaux. Wall began exhibiting his images as transparencies in large light boxes, but he, too, was interested in violence as a subject matter and soon was incorporating the genres of film, advertising, and painting into his works as well. At about the same time that Nicosia's vampire was terrorizing a birthday party, a ventriloquist's dummy in Jeff Wall's retro 1940s birthday scenario was doing similar damage on a monumental scale, but in a more subtle and insidious manner (fig. 7).

A number of things led to the dramatic changes evident in Nicosia's next series of photographs, "Real Pictures." During the previous series, to fill the downtime between the moment when his set was complete and when he could assemble the actors, Nicosia had begun to make graphite drawings, finding himself attracted to the black-and-white palette. He was also still hearing "they're too big, too colorful, and too fabricated" from critical arbiters in the photographic field.[16] Nicosia decided to leave the studio and began to photograph at "real" locations using black-and-white film. It is in these works that Nicosia began to blur the boundary between fact and fiction in earnest. Black-and-white photography, after all, lends the images an air of objective truth, as if they were taken by a photojournalist or someone who happened upon a "decisive moment." Nicosia's trademark humor and vaudeville style were being replaced by a new, almost film noir edge. As one review at the time noted, "This apparently retro move to a traditional photographic look is actually a strategic relocation into a different neighborhood of signs and cues. Nicosia has traded off visual parodic excess and put himself in a position of being less clever, more resourceful...."[17]

In "Real Pictures," seemingly random acts of violence in the suburbs mingle with moments of mischief, rage, cruelty, and fear. *Real Pictures #11* (1988, page 3) catches three children in a backyard watching a sapling they have torched go up in flames. Nicosia has lined the sapling up with a fullygrown tree in a neighbor's yard, heightening our sense of the differences between youth

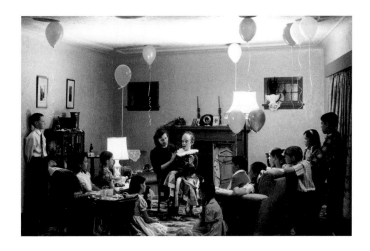

fig. 7 Jeff Wall, *A Ventriloquist at a Birthday Party in October, 1947* (1990), transparency in light box, 90¼ x 138⅝ inches. J.P. Bergmanns/Collection Lhoist, Brussels

and maturity. Nicosia's lifelong fascination with fire finds further expression in *Real Pictures #19* (1989, pl. 20) in which a father and son discover a fire that has been set outside their front door. The scene takes place at night, enhancing the dramatic impact, and we "see" the event through a car window, placing us in the position of accomplices watching from the getaway car. Another car window, this time a windshield, frames *Real Pictures #10* (1988, pl. 19). In this photograph, we look on helplessly as a raging pit bull terrier appears to savagely leap onto the hood of the car threatening us, the passengers, within. Further up the driveway, we see a toddler at play and know instantly that even that quintessential symbol of suburban safety, the Volvo stationwagon parked next to the young girl, couldn't save her from the pit bull should the dog turn his attention away from us. Nicosia has made the print as large as a windshield, serving up his suburban terror lifesize.

A glance out a friend's studio window one day led Nicosia to create *Real Pictures #8* (1988, pl. 18), as it seemed a perfect frame for a random act of violence. Clowns are symbolically charged characters to begin with, and as we look down on the street from this window above, we see a fullycostumed clown holding a bunch of balloons and making an obscene hand gesture at a man just up the street who, leaning out of a 1955 Pontiac, is about to hurl a liquor bottle. The old car and the dated-looking window panes lead one to wonder if it is a mere coincidence that Nicosia's photo was staged not far from where President Kennedy was shot from an upstairs window of the Texas Schoolbook Depository.

Nicosia jokes that *Real Pictures #2* (1987, pl. 17) was made right around April 15 when federal income tax returns are due. In this image, three armed "G men" are leaping from their car and chasing a civilian. The dramatic setting—underneath a freeway, with the perspective lines of the girders looming ever larger overhead—heightens our sense that the denouement is imminent. In *Real Pictures #15* (1989, pl. 16), our point of view is different: we are on a bridge looking down into a river over the shoulders of five young girls who have attached a naked doll to a rope and lowered it into the water below, where we see it floating haplessly downstream. One can only guess what is going on in the minds of the participants in this macabre scene. Nicosia recalls this image being inspired by Jacques Tati's 1953 film, *Mr. Hulot's Holiday*. The opening credits for the film, which extend the following invitation, relate in many ways to some of what we discover when looking at Nicosia's works:

> Mr. Hulot is off for a week by the sea.
> Take a seat behind his camera and you can spend it with him.
> Don't look for a plot, for a holiday is meant purely for fun,
> and if you look for it, you will find more fun in ordinary life than
> in fiction.
> So relax and enjoy yourselves.
> See how many people you can recognise.
> You might even recognise yourself.

In *Real Pictures #6* (1987, page 2), death itself is the final arbiter. Set in a body of water at the base of a large rocky cliff where Nicosia played as a child, three girls and a grandfather figure have come across a dead body wedged in between two boulders in the water. The grandfather is urging the girls not to look, but they can't help themselves. He reaches his hand out to them in the same way that Poussin's all-knowing female figure of death reaches out to the three young shepherds who are realizing that *Et in Arcadia Ego.*

It is interesting to note that in 1989, when Nicosia was creating his "Real Pictures" series, he also began to accept portrait commissions (figs. 8–19). It began inadvertently when a collector of his work agreed to sit for a portrait only if Nicosia took it. Since then, Nicosia has fulfilled hundreds of portrait commissions around the world. Unlike such artists as Andy Warhol and Robert Mapplethorpe, whose portraits have always been seen as an integral part of their oeuvre, Nicosia saw the portrait commissions and his other photographs as separate entities. However, all of the psychology and drama witnessed as sitters put themselves and their children before him has had an enormous impact on Nicosia's art and vice versa. Nicosia now acknowledges that what he at first saw as a side business has in fact proved to be an invaluable source of research. Stylistic solutions achieved in his portraits have found their way into his artwork (fig. 34, pls. 33–35). In recent years, Nicosia has begun to do commissioned portraits in which he creates a kind of genre scene using a family in its own home (figs. 13, 18). Informally called "A Day in the Life of . . ." this group of portraits utilizes strategies and techniques developed in several earlier art series.

Windows of different kinds often play a role in Nicosia's work, and in *Real Pictures #14* (1989, fig. 23), we are looking through a "window" created by an opening in the trees. The scene before us is one where two girls have just taken off a young boy's pants and are taunting him with them. Our vantage point, literally peeking through the bushes, and the subject matter of private humiliation make us feel more like voyeurs than viewers. In his next series, "Love + Lust," Nicosia would push the voyeuristic envelope even further. In this series, sex as a subject infiltrates the suburbs in many guises. Given the intimate nature of the images, Nicosia chose to make smaller prints for this series (each approximately 30 x 30 inches), and he removed them one step from reality and closer toward the zone of erotica (of "blue" photographs) by toning them in various shades of red, flesh, green, and blue. In *Love + Lust #1* (1990, fig. 21), we really are Peeping Toms as we gaze through a window in a wall at night to see a woman on a back porch dancing in a bikini, trying to sexually arouse a seated man drinking coffee. In *Love + Lust #11* (1990, pl. 21), a young woman, post coitus, cools off with a fan blowing up her skirt (à la Marilyn Monroe in *The Seven Year Itch)* while her

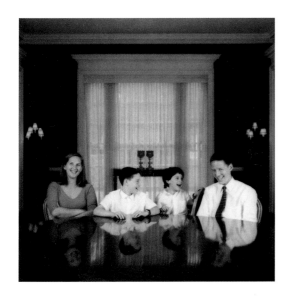

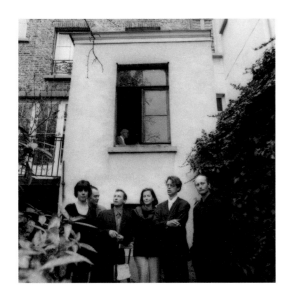

top to bottom:
fig. 8 Houston, Texas, 1999
fig. 9 Dallas, Texas, 1998
fig. 10 Ghent, Belgium, 1994

fig. 11 Chicago, Illinois, 1994
fig. 12 Glencoe, Illinois, 1994
fig. 13 Highland Park, Illinois, 1999

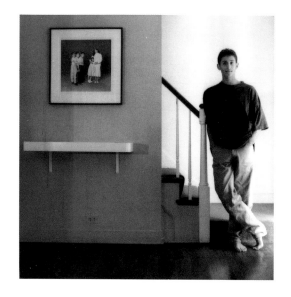

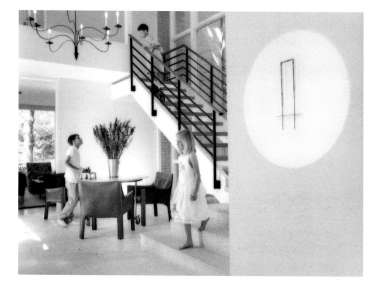

top to bottom:

fig. 14 Glencoe, Illinois, 1994
fig. 15 Cama, Washington, 1997
fig. 16 Kortrijk, Belgium, 1994

fig. 17 Meulebeke, Belgium, 1994
fig. 18 Dallas, Texas, 1998
fig. 19 Minneapolis, Minnesota, 1998

partner appears to lay exhausted in bed. A pair of women who appear to be a mother and a daughter examine a nude man's genitalia in an incongruous living-room setting in *Love + Lust #14* (1990, pl. 24), and in *Love + Lust #13* (1990, pl. 22), we peer into a teenage boy's bedroom through a crack in his door during a private moment when he appears to be exploring his own sexuality. The works in this series are more intimate and introspective than Nicosia's previous works; the actors no longer appear to be playing to an audience. Like the painter Eric Fischl, Nicosia is mining the realm of sexual frustration in the American suburbs in a cinematic way. Yet Nicosia never shows us anything graphic, preferring to call upon the more potent power of suggestion.

Nicosia has never given his viewers all that many clues with his titles, but in his next series from 1991–93, "Untitled," he really shuts us out, leaving us completely on our own. He began the series uncharacteristically with a set of self-imposed parameters: the photographs could be taken only at his home or at his previous home; they could include only members of his family or of the family living in his previous home (who were close friends); they must all be taken at night; and the photographs must be black-and-white and uniform in size (36 x 36 inches). Nicosia imposed these guidelines at the time when he was particularly busy with portrait commissions and knew he had to structure things a bit differently if he was to continue with his art-making.

The "Untitled" images have much in common with sixteenth and seventeenth-century Dutch genre paintings. They depict family members gathered together in the home, engaged in a variety of seemingly mundane activities. They are enhanced by interesting architectural settings and assorted symbolic accouterments and possessions. Still, while Nicosia's images may seem as quiet as a Vermeer on the surface, underneath they are seething.

Several of the images explore relationships between fathers and daughters, a subject close to Nicosia's own heart. In *Untitled #2* (1991, pl. 30), a man sips his coffee in the midst of two girls playing dress-up, seemingly lost in their own daydreams. *Untitled #9* (1992, fig. 1) presents a relationship of a different kind: here you could cut the tension with a knife. A man and a young girl in a bathing suit confront one another on a sidewalk leading up to a house. She has taken a firm stand, spreading her legs and shining a flashlight on his chest. He has stopped in his tracks. We can't see either of their faces, which means we don't get to share in their dialogue—we're kept at bay. Perhaps it is a playful gesture on the little girl's part, but as one critic has noted, "Something impure lurks beneath the surface, but it is difficult to determine whence that potential nastiness springs. Nicosia provides nothing to alleviate or corroborate the sordid suspicions."[18]

Nicosia's fondness for Edward Hopper's paintings can also be found in this series. Nicosia has great respect for Hopper's symbolic use of light, and in these works, like Hopper, he uses both the light and architecture to create a heightened sense of isolation and vulnerability. One Hopper scholar has noted that "Hopper's paintings are about quiet, lonely, and obscure defeats, those which have happened, are happening, or are about to happen."[19] That statement could also very easily apply to these photographs. In *Untitled #5* (1991, pl. 31), a man and a woman at a candlelit table are sitting next to each other but are figurative miles apart. She's so uninterested that she's playing with her hair, using her reflection in a knife as a mirror. He's so bored that he has created a culinary sculpture out of items scavenged off the table: its balance appears to be as precarious as their relationship. They are the all-too-common couple who sit at dinner night after night with nothing to say to one another.

The young girl who appears repeatedly in this series plays the victim in several of the photographs. In *Untitled #6* (1992, pl. 26), she is the victim of her parents' high expectations, standing alone in a spotlight in her ballet costume while her parents size her up from the room's shadowy recesses. In *Untitled #7* (1992, back cover, pl. 32), the little girl is in bed, experiencing every child's fear of a stranger appearing at their window at night. In this case, the stranger has cast a shadow on the wall that looks suspiciously like Barbie, whose anatomically impossible figure has haunted many a young girl as she moves into womanhood.

One critic has noted, "The tone of mystery in these images recalls scenes from movies by Alain Resnais and Andrei Tarkovsky."[20] They also call to mind Luis Buñuel's view of film as "the nocturnal voyage into the unconscious."[21] When reviewing this series, Vince Aletti concluded, "Equal parts ennui and menace animate these suburban noirs, and nearly every image contains a psychological time bomb that might or might not go off."[22]

After the "Untitled" series, Nicosia wanted a break from the constraints of working with actors. To simplify things, he also returned to working in the studio where he had more control. In "Acts 1–9," we see him incorporating the more minimalist style developed in the studio with his portrait commissions. Pared-down sets, dramatic lighting, and a diffuse style of printing helped Nicosia to get away from his previous filmstill and fabricated looks toward a new sense of the theater stage. In *Act 4* (1994, pl. 33), Nicosia sets the stage for the myriad associations one could make between a young boy and a sexually mature woman using only a minimum of components: a boy, a woman, and a chair; a stage, a spotlight, and a gesture. In *Act 5* (1994, pl. 34), Nicosia's "shadow man" steps forward as a representative of the subconscious world, casting his haunting spectre. And in *Act 9* (1994, pl. 35), Nicosia himself appears, aged with makeup beyond his years, to stand in front of the lights and face the darkness ahead. For this series, Nicosia went back to making larger prints (up to 49 x 62 inches) and used oil paint to give them a blue cast, creating a cool, foreboding tone.

iven his highschool adventures with a Super-8, his university background in film and communications, and his ongoing love of film, it is no wonder that Nicosia eventually made his way back to moving pictures. It is also interesting to note that a number of Nicosia's contemporaries who were also making staged photographs in the 1980s and 1990s made the same leap from still photography into film and video.[23] The impulse to set those narratives into motion would seem only natural. In Nicosia's *So…You Wanna Be an Artist* (1997, pl. 36), "shadow man" appears again and wastes no time before challenging our sense of security. When he made this video, Nicosia himself was approaching mid-life, trying to cover two college tuitions, and in general feeling pressure all around—the kind of time when one is prone to reassess one's life's choices. "Shadow man" steps onto the stage, asks his question, and then proceeds to have a great long laugh at our expense. This comic assault on our self-confidence is over in less than a minute.

Nicosia then embarked on a more ambitious video, *Middletown* (1997, fig. 24, pls. 37–44). The title is a play on the name of the street that Nicosia lives on, Middleton, and the street itself is the star of the show. The video takes us around and around the neighborhood, again and again, viewing all of the goings-on, both surreal and mundane, through a car windshield. It is as if Nicosia's "Real Pictures" have come alive. Dramas unfold, but they are essentially as aimless as Mr. Hulot's holiday. The cinematography and the lilting tempo of the soundtrack make you feel like you're a kid without a care in the world, riding your bike around the neighborhood, aimlessly observing the world from the vantage point of the street where you live. It is a suburban version of Walter Benjamin's "flaneur," the gentleman who strolled idly about the city, noting and observing. The video's sepia-toned coloration heightens our feelings of nostalgia, as does the playfully engaging soundtrack inspired by Danny Elfman's score for *Edward Scissorhands*, Tim Burton's 1994 film that explored the "pastel paradise known as suburbia."[24] Nicosia's video is a technical tour de force made in one scene, one take, fifteen minutes long. In the cinematic pantheon of single takes, it's not the Mexican border town in Orson Well's *Touch of Evil* (1958) or Robert Altman's Hollywood in *The Player* (1992). It's just Nic Nicosia's surreal ride through a place called home, where life appears to be stranger than fiction.

Nicosia went for the long single-take effect again in *Moving Picture* (1998, pls. 45–48). Shot in 16mm film, it begins with the sentimental cliché of a camera flare in a light-filled sky. As we make our way down through the trees, Nicosia seduces us with the melodious chatter of songbirds until we enter a classic suburban colonial-style home, loaded with what realtors call "curb appeal." A plaintive tune with a Roy Orbison-like twang takes us on a tour of this pseudo-stately home. As we meander through,

we pass by assorted inhabitants, each isolated in his or her own world. It becomes a bit like a reunion or "old home week," with cameo appearances by such longstanding members of Nicosia's troupe as shadow man, fire, the house of cards, the laser gun, and yet another sacrificial doll (fig. 20). The journey reaches a climax when three generations of the home's seemingly dysfunctional family actually come together around the dining room table for dinner. Relieved and reassured that all is well in the world, Nicosia allows us to proceed out the way in which we came.

Nicosia's most recent film, *Middletown Morning* (1999, cover, fig. 32, pls. 49–54), is an antic bit of staged cinema verité that opens with a medley of classic suburban white noise: the rhythmic "chicka, chicka" of lawn sprinklers and the faraway sound of dogs barking. In this film, Nicosia presents just another morning in the life of an artist, his wife, their baby, their nanny, and the neighborhood paperboys.[25] It takes place in a decidedly minimal '90s home: no lawn, white carpet, void of chotchkas but full of technology. An insistent and monopolizing cell phone, a new addition to Nicosia's suburban iconography, makes an impressive debut and is joined by a noisy clock radio, a coffee maker, a glistening black Jeep Cherokee, and a malfunctioning garage door opener.

The soundtrack's peppy get-you-going-in-the-morning music leads us through a morning of life's little mishaps: the newspaper lands in the water fountain; the baby starts crying just when the parents have snuggled back under the covers; the phone rings with a wrong number just as Dad is lifting the baby out of the crib; and the garage door won't close.

Nicosia himself plays the role of the artist and embellishes it with a healthy mix of paranoia and bonhomie. He reads a review of his work in the day's *The New York Times* while talking to his Italian dealer on the cell phone. He's agonizing over every

fig. 20 Nic Nicosia, still from *Moving Picture*, 1998, 16mm film. Courtesy the artist, Dunn & Brown Contemporary, Dallas; P·P·O·W, New York; and Texas Gallery, Houston

perceived innuendo as his dealer does her best to try to reassure him whenever the line isn't breaking up. In a humorous self-reflexive gesture, the car radio only seems to be playing songs from Nicosia soundtracks that morning, and the "morning" ends when, as luck would have it, the artist's car, en route to the studio, gets hit in the windshield with another of the paperboys' misguided newspapers.

Nic Nicosia has spent virtually his entire life in Dallas, far away from the art and film hubs of New York and Los Angeles. Some might wonder why an artist like Nicosia would choose to remain in such relative isolation, but looking at the past twenty years of his work, one can see that this community has been his unwavering muse, his font, and his source. It has provided him a ringside seat on middle-class life deep in the heartland of America. The women are no more "strong," the men no more "good looking," and the children no more "above average" in Nicosia's "Middletown" than they are in Lake Wobegon. The American dream is just that, a dream, and Middletown is full of violence, lust, despair, and cruelty. If the home fires are burning, more likely than not it's because some children have torched a tree in your backyard.

But the great thing about dreams is the hope that they can instill. Despite all of Middletown's flaws—and there are many—it's not such a bad place to be. Nicosia has admirably stuck with his muse through thick and thin, indirectly sharing with us his own childhood and adulthood, as well as his sorties into marriage, parenthood, and mid-life with all of the bumps and bruises along the way. In so doing, the lines between tragedy and comedy, as between fact and fiction, have blurred. Middletown is patently false, but it is also very real.

In 1973, Bill Owens published a book of photographs entitled *Suburbia*.[26] Using both photographs and texts, he dismissed life in a development of new tract homes and among its inhabitants as superficial and shallow. Eighteen years later, on the occasion of a survey of photographs of domestic life, Peter Galassi would write, "Shooting down the American Dream has become easier than shooting fish in a barrel, and a lot more common."[27] Looking at the last twenty years of Nicosia's works, one can see that when all is said and done, he's chosen not to shoot down the American dream. Rather, he's chosen to plumb the suburban subconscious, in whose depths we discern a romantic streak beneath Nicosia's cynicism, slapstick, and black humor—a compassionate sympathy propelled by an unwavering strain of honesty. Nicosia, we discover, is a closet humanist and he's breaking it to us gently. In spite of everything—the good, the bad, and the truly ugly— for Nicosia, home is still where the heart is.

Notes

1. Arcadia is a region from classical history that has come to symbolize an idyllic place. Poussin's shepherds discovered the enigmatic inscription, "Even in Arcadia go I" at the same moment that a female figure, thought to represent death, appears before them, reminding them of their own mortality.

2. A.D. Coleman, one of the few art critics writing about photography at the time, introduced this term in a seminal essay published in 1976, "The Directorial Mode: Notes Toward a Definition." It can be found in Coleman's *Light Readings: A Photography Critic's Writings 1968–78* (New York: Oxford University Press, 1979), pp. 246–257.

3. Such a laborious task seems almost unthinkable today in an age when similar changes can be made almost instantaneously with digital technology.

4. To be labeled a "photographer" at this time meant possibly missing out on the opportunity to be seen within a larger context. Artists like Cindy Sherman, who was working solely with photography, had to struggle to make sure that her work wasn't "ghettoized" into photography-only exhibitions, thereby excluding it from a larger dialogue.

5. From a conversation with the artist, July 2, 1999.

6. Nicosia saw the catalogue and later some of the photographs in Dallas. The artists in this exhibition were Ellen Brooks, James Casebere, Stephen Collins, Robert Cumming, Phillip Galgiani, Leslie R. Krims, John Pfahl, Donald Rodan, Victor Schrager, and Carl Toth.

7. Susan Sontag, *On Photography* (New York: Farrar, Straus and Giroux, 1977).

8. Jonathan Green, *American Photography: A Critical History 1945 to the Present* (New York: Harry N. Abrams, Incorporated, 1984), p. 176.

9. From a conversation with the artist, July 2, 1999.

10. Brian Lukacher, "Powers of Sight: Robinson, Emerson, and the Polemics of Pictorial Photography," in *Pictorial Effect Naturalistic Vision: The Photographs and Theories of Henry Peach Robinson and Peter Henry Emerson* (Norfolk, Va.: The Chrysler Museum, 1994), p. 34.

11. From a conversation with the artist, July 2, 1999.

12. Janet Kutner, "Photo Unreality," *The Dallas Morning News*, February 2, 1986, p. C9.

13. Ibid.

14. From the song, "Life As We Know It" (1987) by Dave Hickey.

15. Eleanor Heartney, "Nic Nicosia: Albert Totah," *ARTnews*, May 1987, p. 153.

16. From a conversation with the artist, July 2, 1999.

17. Ed Hill and Suzanne Bloom, "Nic Nicosia: Texas Gallery," *Artforum*, September 1988, pp. 148–49.

18. Alisa Tager, "Nic Nicosia: Linda Cathcart," *ARTnews*, March 1994, p. 143.

19. J.A. Ward, *American Silences: The Realism of James Agee, Walker Evans and Edward Hopper* (Baton Rouge and London: Louisiana State University Press, 1985), pp. 191–92.

20. Charles Hagen, "Nic Nicosia: P•P•O•W Gallery," *The New York Times*, June 24, 1994, p. C17.

21. Pauline Kael, *The Citizen Kane Book: Raising Kane* (Boston: Little Brown, 1971), p. 14.

22. Vince Aletti, "Voice Choices: Nic Nicosia," *The Village Voice*, July 5, 1994, p. 68.

23. Cindy Sherman released a feature film, *Office Killers*, in 1998. Sandy Skoglund has made films, and Tina Barney has made documentaries on the artists Horst P. Horst and Jan Groover. At one point in his career, Jeff Wall almost set out to become a filmmaker.

24. Text taken from the video cover of *Edward Scissorhands*, 1994.

25. While working on this film, Nicosia was also writing a sitcom that chronicles the antic life of an artist.

26. Bill Owens, *Suburbia* (San Francisco: Straight Arrow Books, 1973).

27. Peter Galassi, *Pleasures and Terrors of Domestic Life*, (New York: The Museum of Modern Art, 1991), p. 17.

Early Works

1979–81

I started to make and show still photographs in the mid to late
'70s, a couple of years after graduating with a degree in radio/TV/
film with an emphasis on film. At that time, Susan Sontag's *On
Photography* had created a lot of discussion as to the truth in
photographs and photographic information. Within the realm
of film, there seemed to be very little discussion on the camera's
ability to lie. It was just the tool that you needed to make your
staged and acted movies. I used the still camera in the same way,
with its ability to blend fantasy and reality. Yes, the camera can
tell the truth; no, it can't lie, but it can record a lie.

These works were my first attempts to use the devices of
movie set and location manipulation to make still photographs,
by adding or subtracting information on the surface of the actual
print, and eventually on the objects being photographed. It was
tweaking the information, manipulating it to create something
other than a representation. At the time, distancing my work
from traditional photographic concerns was part of the content
and the reason for fabrication and the use of large color images.

The locations I had picked were landmarks around places
where I'd lived, like convenience stores, mailboxes and frequented
diners. *Cityscape #1* (1980, fig. 5) was the view I had for five years
outside the camera shop I opened and owned after college. That's
another story, but the store is where I learned about still cameras.

—*Nic Nicosia**

*Comments on this and succeeding series titlepages have been
taken from conversations with the artist, summer 1999

1. **Wall Paper**, 1981
Chromogenic photograph
20 x 30 inches
Courtesy the artist, Dunn & Brown Contemporary, Dallas;
P•P•O•W, New York; and Texas Gallery, Houston

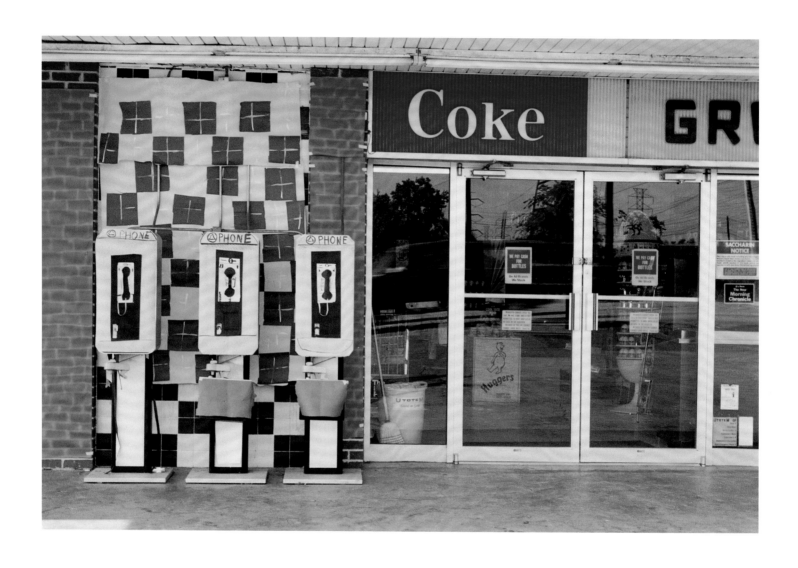

2. **Pay-Per Phones**, 1980
Chromogenic photograph
20 x 30 inches
Private Collection, Houston

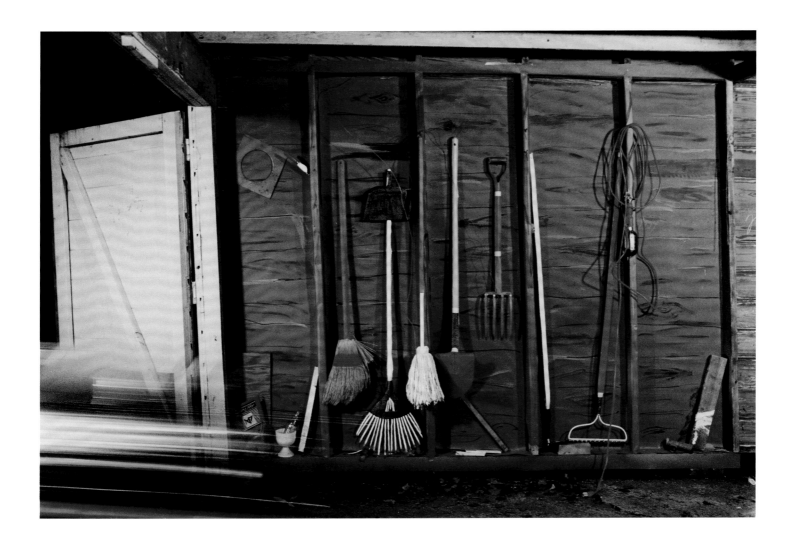

3. **Composition**, 1980
Chromogenic photograph
19 x 29 inches
Courtesy the artist, Dunn & Brown Contemporary, Dallas;
P•P•O•W, New York; and Texas Gallery, Houston

Domestic Dramas

1982

Domestic Dramas

I was married—still am—and our two daughters were very, very young. There were a variety of domestic situations. I had a desire to be completely in control of every aspect of the image and content, and to be physically involved with that process. It was necessary to make it obvious that the image was totally fabricated and the information was manufactured.

The people in these photographs were friends (or friends of friends) and family. Everyone seemed to like being in these pictures and therefore took direction well.

—*N.N.*

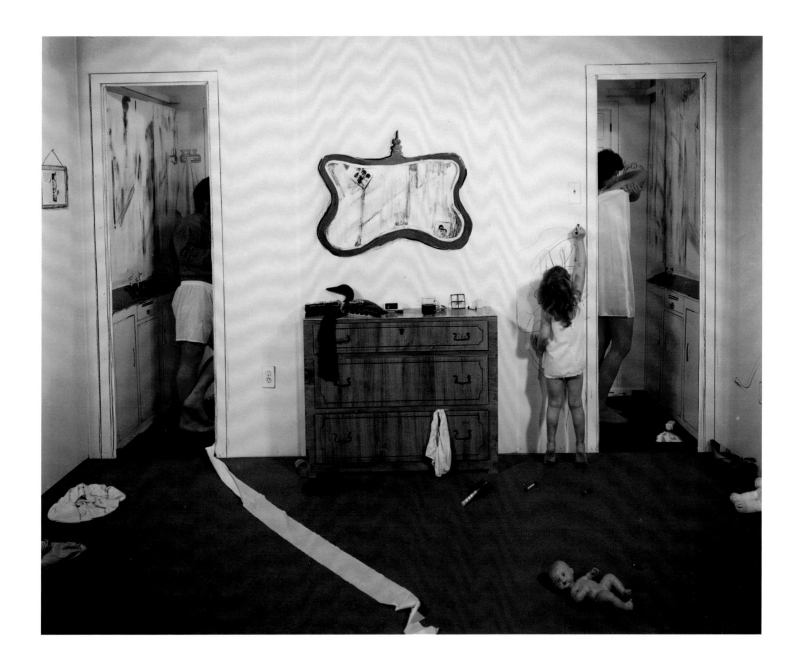

4. **Domestic Drama #1**, 1982
Chromogenic photograph
30 x 40 inches
Photography Collection, Harry Ransom Humanities Research
Center, The University of Texas at Austin

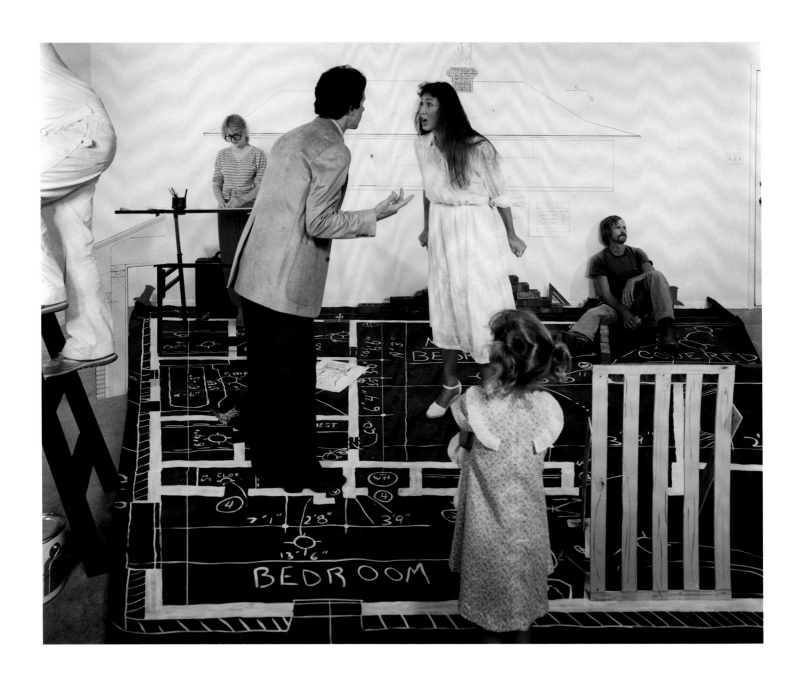

5. **Domestic Drama #3**, 1982
Chromogenic photograph
30 x 40 inches
Courtesy the artist, Dunn & Brown Contemporary, Dallas;
P•P•O•W, New York; and Texas Gallery, Houston

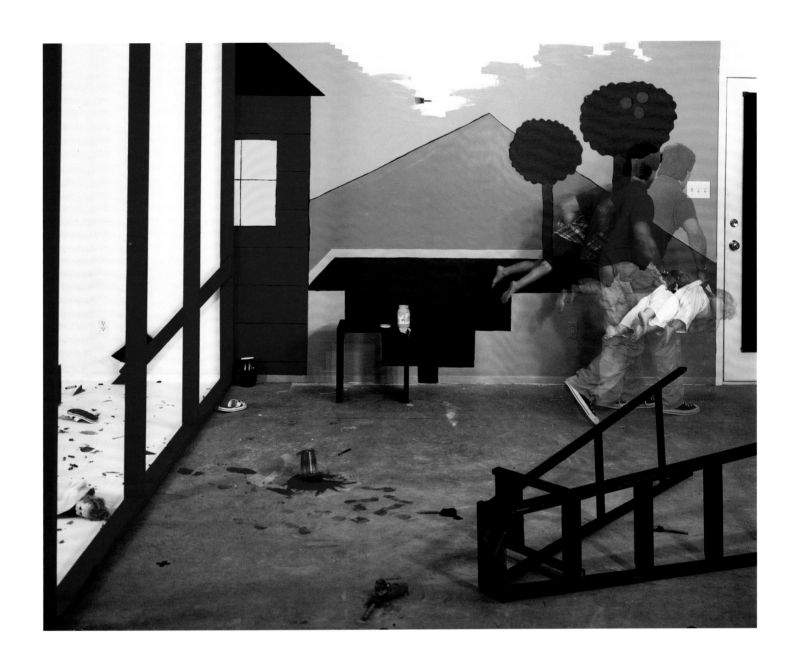

6. **Domestic Drama #6**, 1982
Silver dye bleach photograph
40 x 50 inches
Courtesy the artist, Dunn & Brown Contemporary, Dallas;
P•P•O•W, New York; and Texas Gallery, Houston

Near (modern) Disasters

1983

In terms of method, this series is somewhat of a continuation of the "Domestic Dramas," but with larger sets and more people. I began looking at a lot of architecture and exploring ways to incorporate its features into my sets and set building. The design and building of each set was first and foremost. In other words, for some of the pieces, the set preceded the idea for the action.

I came across an aircraft cable that is $1/16$th-of-an-inch thick and can hold something like 480 pounds. It was perfect for this work. Hurricanes, earthquakes, people flying through some kind of disaster . . . it was like the cartoons.

—N.N.

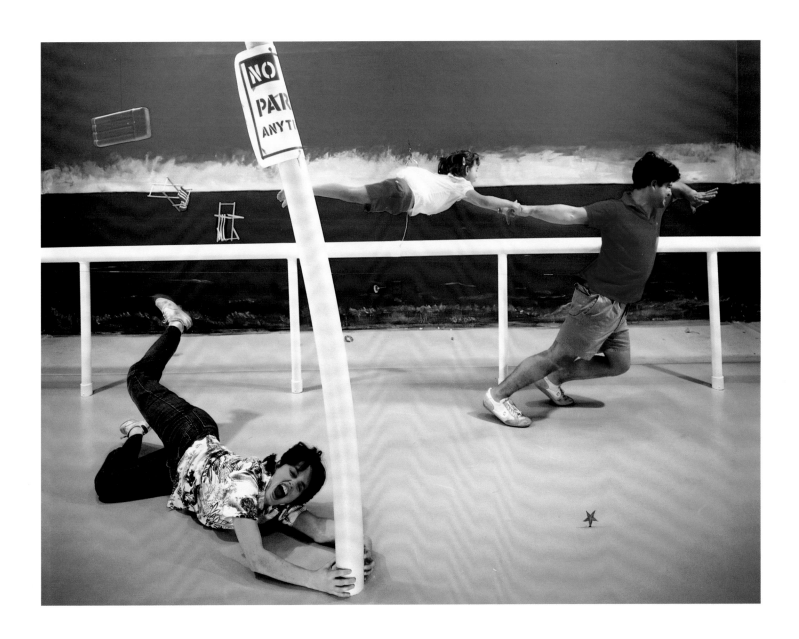

7. **Near (modern) Disaster #8**, 1983
Silver dye bleach photograph
40 x 50 inches
Collection Cece Smith and John Ford Lacy, Dallas

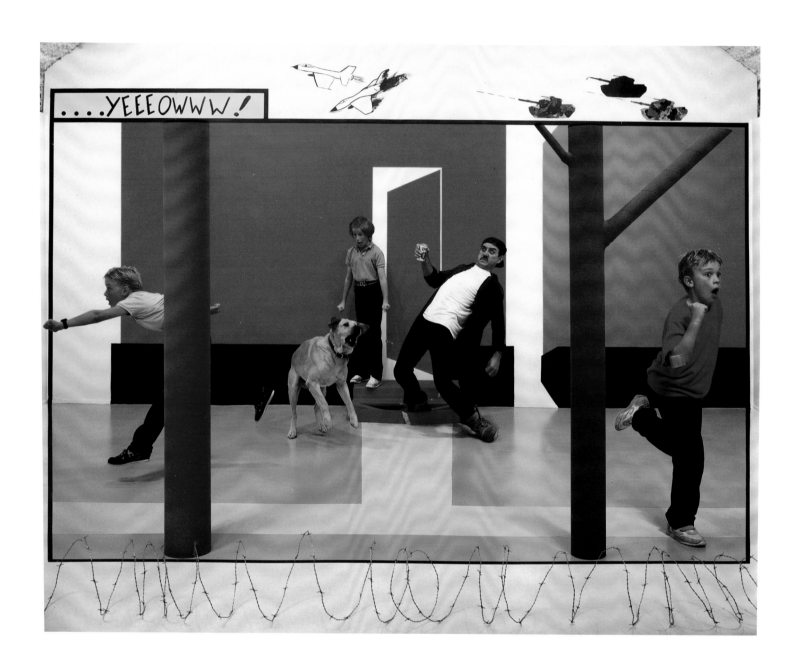

8. **Near (modern) Disaster #7**, 1983
Silver dye bleach photograph
40 x 50 inches
Collection Frito-Lay Inc., Plano, Texas

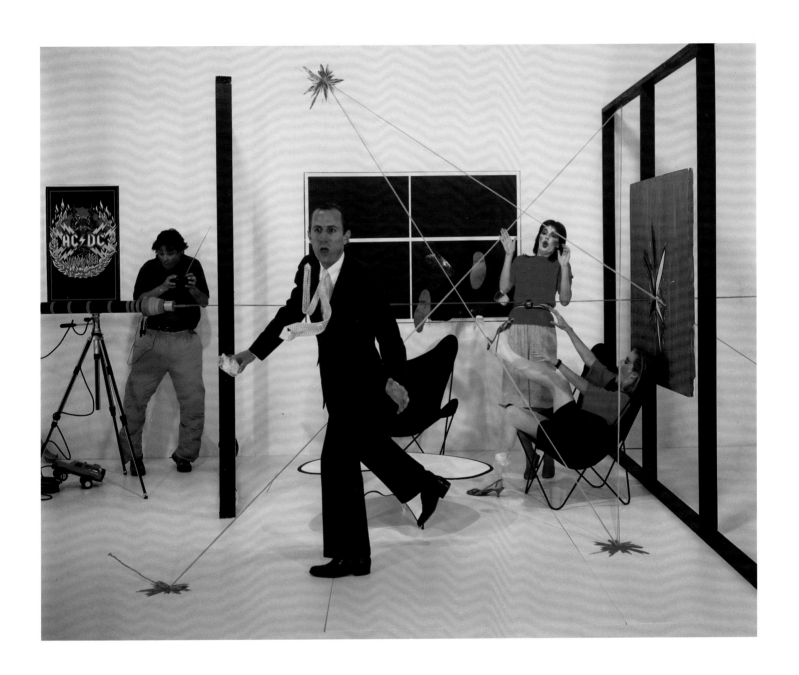

9. **Near (modern) Disaster #2**, 1983
Silver dye bleach photograph
40 x 50 inches
Collection Frito-Lay Inc., Plano, Texas

The Cast

1985

The Cast

I felt my work was in need of better character development in order to progress to images of more complex content. I cast people based on their physical features, knowing that with the addition of wigs, make-up, facial hair, and costuming, a new character—one that fit the part—would be created. I needed this series.

Once the actor put on whatever make-up and costuming was designed for the piece, they basically became that character. The series was about the way someone looks and the way we project what they are like based on appearances. For the most part, people make conscious decisions to look a certain way, and they hope you will get it.

In a way, these were like my first portraits.

—N.N.

opposite:
10. **Bill and Pete**, 1985
Silver dye bleach photograph
50 x 40 inches
Courtesy the artist, Dunn & Brown Contemporary, Dallas;
P•P•O•W, New York; and Texas Gallery, Houston

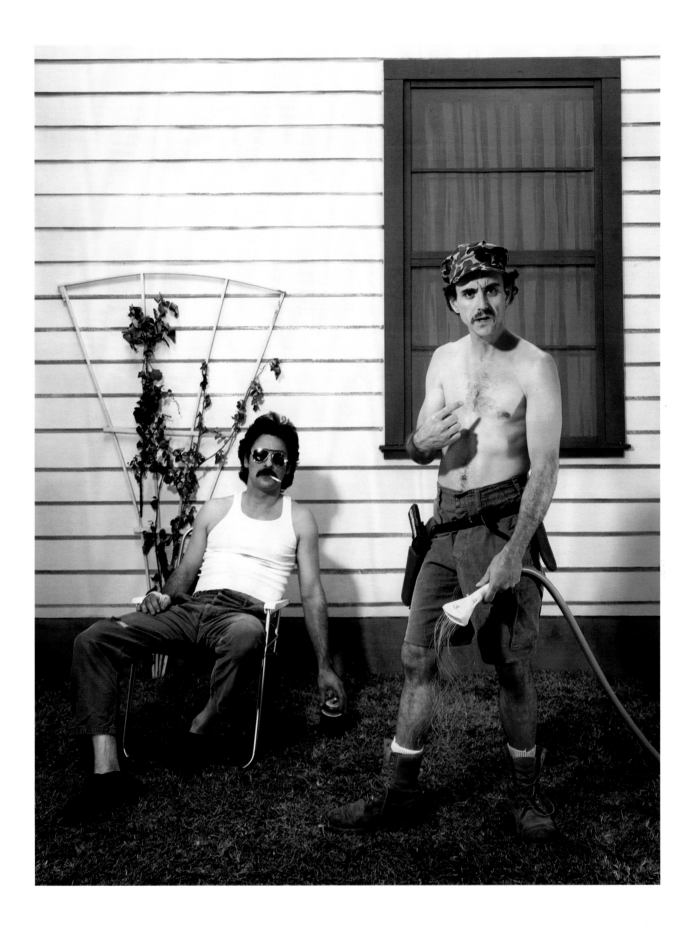

11. **Tristano**, 1985
Silver dye bleach photograph
40 x 43 inches
Courtesy the artist, Dunn & Brown Contemporary, Dallas;
P•P•O•W, New York; and Texas Gallery, Houston

12. **Ms. D'Avignon**, 1985
Silver dye bleach photograph
40 x 47 inches
Courtesy the artist, Dunn & Brown Contemporary, Dallas;
P•P•O•W, New York; and Texas Gallery, Houston

Life As We Know It

1986

This really wasn't supposed to be a series, as I wanted to get away from thinking in those terms. The obvious staging was no longer important, that point had been made; and although content was always meaningful to me, the fabrication was becoming a distraction. I was trying to make the sets look realistic (trompe l'oeil) and the use of dramatic lighting was necessary to complete the illusion.

I also wanted to add another dimension, something with sound. Enter Dave Hickey, and his songs based on my pictures. Dave's album title is *Life As We Know It*. That also became the title for the series. Yes, it became a series.

The influences came from outside the domestic realm and reflect on contemporary life, art, and fashion. It was a time when neo-expressionist painting was falling out of fashion and neo-geo was in. Art Deco was back, again. Then there was the space shuttle tragedy, several car bombings and plane crashes, and a couple of wars broke out. Some professional athletes dropped dead from cocaine abuse. It was a time of excessive sudden death and violence.

—N.N.

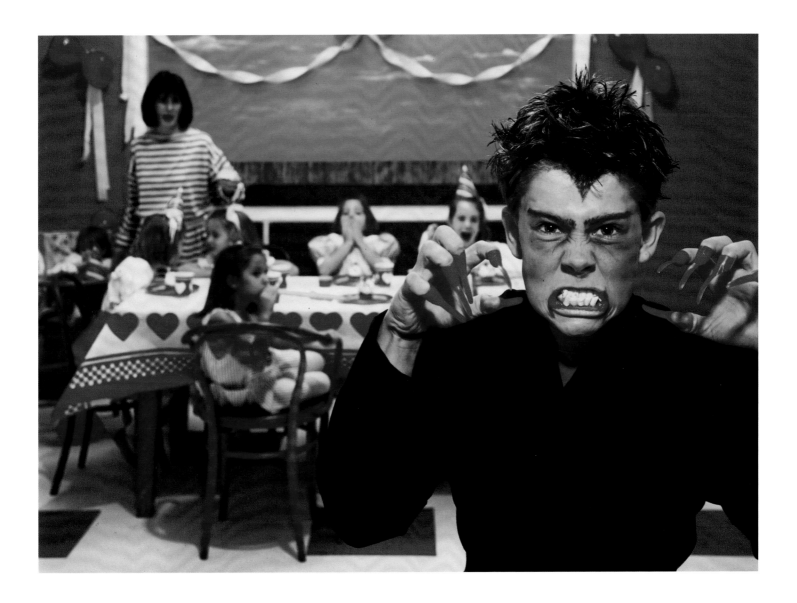

13. **Untitled (Sam)**, 1986
Silver dye bleach photograph
48 x 67 inches
Collection Dallas Museum of Art, The Karl and Esther
Hoblitzelle Collection, Gift of the Hoblitzelle Foundation

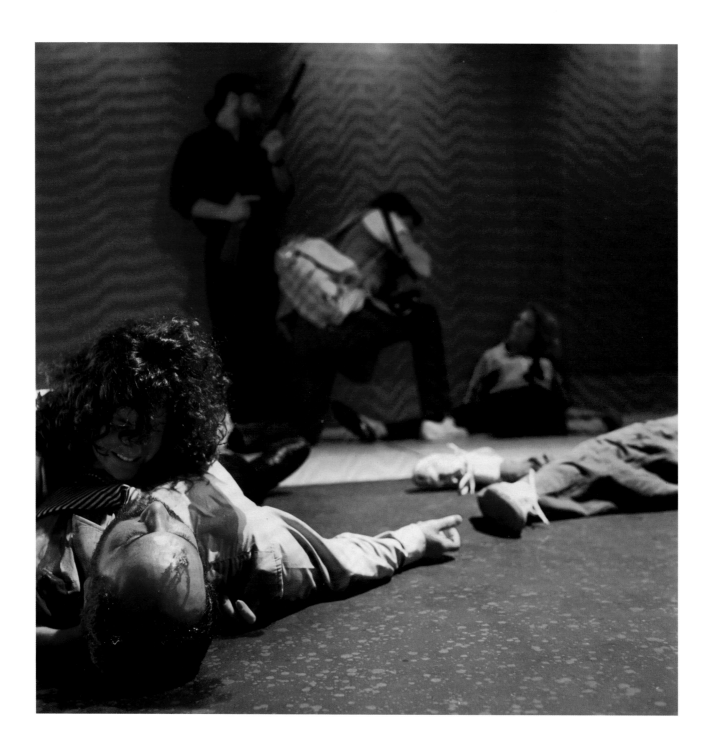

14. **Like Photojournalism**, 1986
Silver dye bleach photograph
48 x 48 inches
Collection Dallas Museum of Art, The Karl and Esther
Hoblitzelle Collection, Gift of the Hoblitzelle Foundation

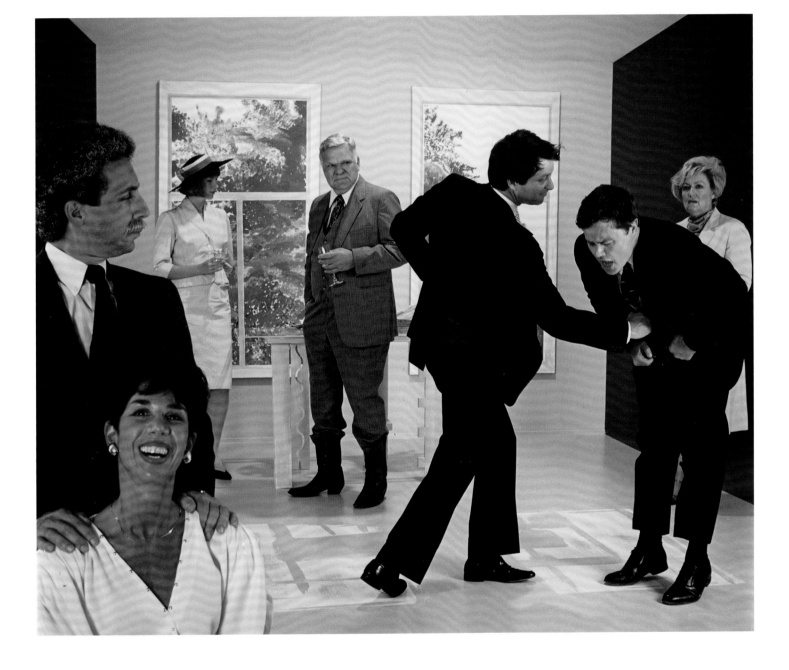

15. **Violence**, 1986
Silver dye bleach photograph
48 x 58 inches
Collection Dallas Museum of Art, The Karl and Esther
Hoblitzelle Collection, Gift of the Hoblitzelle Foundation

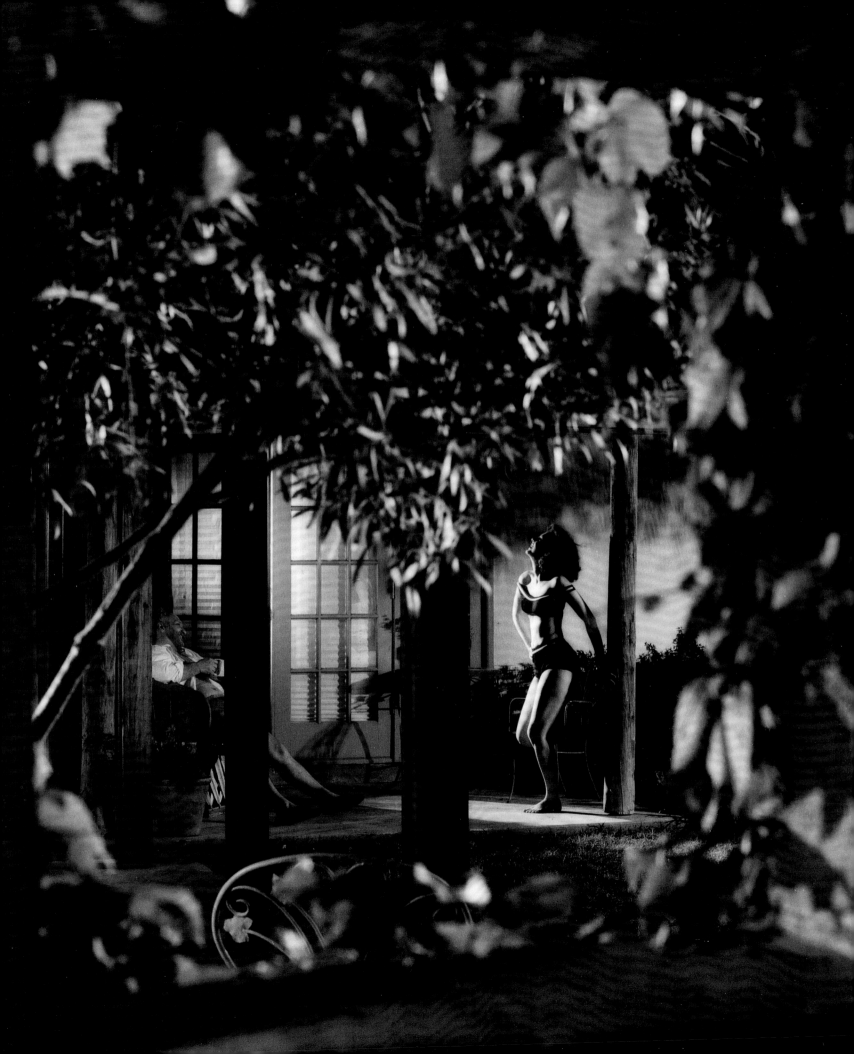

Close to Home

Dana Friis-Hansen

Over the course of his twenty-year career making still and moving images, Nic Nicosia has explored his world through situations staged for the camera. After early experiments altering the surface of photographs, or transforming both outdoor and interior scenes by covering them with colored paper, he went on to produce a number of well-defined bodies of work. Inside the studio, he set up dioramas and added actors for the series "Domestic Dramas" (1982), "Near (modern) Disasters" (1983), "The Cast" (1985), and "Life As We Know It" (1986). Shifting to black and white and moving out of the studio, he created scenes outdoors, mostly neighborhood settings for "Real Pictures" (1987–89) and in domestic spaces (interiors and back yards) for "Love + Lust" (1990–91) and "Untitled" (1991–93). The more theatrical "Acts 1–9" (1994–95) series signaled a return to the studio.

Nicosia has a degree in film and television—not photography. A few years ago, he returned to these media (which he hadn't used since college) to produce his most complex, most powerful work to date. In fact, it is uncanny how his latest work in film and video seems an all-but-inevitable outcome of the photographs that he made over the past two decades: certain themes, ideas, and visual motifs are taken up again for reconsideration in a fluid medium on a bigger screen. Projecting these works alongside the still images illuminates the breadth and depth of the artist's vision.

Considering each series chronologically is the logical way to appreciate Nicosia's creative career, and this is done in the preceding essay and in the sequence of the plate sections. As an alternative, however, I propose to trace several thematic paths through this rich terrain. Limiting his scope to what he knows well and choosing to mine only a handful of issues, from different depths and varying angles, the artist has stuck close to home. Nicosia offers his view of contemporary American existence through his narratives exploring suburbia, the family, the couple, and the

individual. Autobiography is present only as an undercurrent here, not as the subject. But we can see how, over the years, his point of view changed as he himself passed through various roles and life stages: first, a typical young artist experimenting with new ways to represent "reality"; then a husband and father (each with attendant rewards and responsibilities); and finally a man close to the middle of life who now looks at the past, present, and future with different eyes. This essay will examine how Nicosia has probed four themes, concluding with some thoughts on how he has dealt with the challenges of art-making in the 1990s, confronting a fin-de-siècle trouble in paradise.

Suburbia

The stereotypical American suburb—imagine *Father Knows Best, Leave It To Beaver, The Brady Bunch, The Cosby Show*—carries with it a wholesome sense of achievement, safety, and connectedness. But there is also an underside, as Nicosia is quick to reveal—cracks in the smooth veneer, weeds in the garden, and dogs that bite—all symptoms of a stifling conventionality, obsessive homogeneity, and psychological uneasiness. Nicosia himself lives on Middleton Road in suburban Dallas, a few miles from where he grew up, and most of the photographs and film/video works were created in these placid neighborhoods, with friends and local residents as cast members and their homes or yards as sets.

Beginning with his earliest photographic works, such as *Untitled* (1979, fig. 22), *Cityscape #1* (1980, fig. 5), *Mail Boxes* (1980, page 1), and *Pay-Per Phones* (1980, pl. 2), Nicosia chose to create scenes reflecting domesticity and everyday life. Although the small white house of *Untitled* is framed by an industrial metal

fig. 21 Nic Nicosia, *Love + Lust #1* (detail), 1990, silver gelatin photograph with oil tint, 30 x 30 inches. Collection Mr. and Mrs. Sanford W. Criner, Jr., Houston

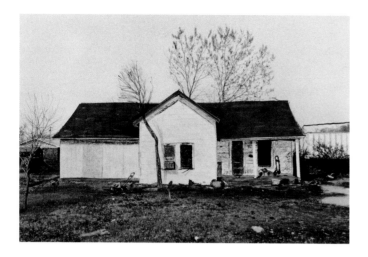

to create interiors set up with handmade and found props, costumed characters, and careful lighting, sometimes adding an element of motion. In this image, an automobile—indispensable in the suburbs—becomes a surrogate for the home owner, exiting the garage in a blur of headlights.

Many of Nicosia's characters are suburban types. Roles in his mini-narratives include cute (and devilish) kids, beleaguered moms and dads, and average working guys, such as *Bill and Pete* (1985, pl. 10) from "The Cast" series. Trying to relax in the backyard (actually a studio set), one in a folding chair drinking a beer and smoking a cigarette, the other watering his lawn, these are not the calmest of neighbors. The gun-toting weekend warrior responds angrily to someone outside the scene, perhaps a pesky kid from next door or his own nagging wife with a long "honey-please-do" list.

Many images of the 1987–89 "Real Pictures" series bring to light the sinister side of children at play in suburbia's yards, woods, and streets. Left to their own devices, the kids of this neighborhood have developed a distorted sense of fun, friendship, and adventure. A doll on a rope is rescued (or drowned?) by a gang of girls on a bridge in *Real Pictures #15* (1989, pl. 16). In a faraway clearing, a young boy writhes in only his underwear while an older girl dangles his pants just beyond his reach in *Real Pictures #14* (1989, fig. 23). In *Real Pictures #18* (1989, fig. 30), five kids lie submissively in a line while a junior Evel Knievel poised on a bicycle at the top of a hill starts down towards a

warehouse and a brick ranch home in a marginalized small town, we nonetheless can pick out certain icons of suburbia, such as a lawnmower, a doghouse, and a lone tree, which would soon become Nicosia trademarks. This early image was obviously photographed from the sidewalk, at a respectful distance, but later work gets closer in, shot from the vantage point of someone inside the community or, like a voyeur, through a gap in the fence. Still in an early, very investigatory phase, he created this work and *Cityscape #1* (fig. 5) by overlaying the original photograph with bits of paper, then drawing on those fragments or collaging other elements, and finally rephotographing the piece to achieve a hybrid texture within a seamless surface. For other early works he transformed a roadside culvert, picnic tables in a park, a street corner, and the convenience store near his home with construction paper before he photographed them, both enhancing the color and flattening the surfaces of these public landscapes. While confounding the specific properties of painting, sculpture, site-specific installation, and photography, these surreal, funky images called attention to the surrounding visual order and local color which we often take for granted.

Another colored paper project, *Composition* (1980, pl. 3) further established the artist's suburban vocabulary and led to his more complicated studio setups with controlled lighting and implied action. The title could as easily apply to a traditional still-life painting or early twentieth-century abstraction, and we have elements of both in the rhythmic arrangement of yard and garden implements on a wall that has been covered with brown paper and painted with imitation wood grain, recalling Pablo Picasso's early Cubist collages. Although not part of an established genre, this garage interior does (slyly) recall the straightforwardness of the nineteenth century trompe l'oeil still lifes of William Harnett (1842–92) and John Peto (1854–1907), or details from the rural farm scenes of 1930s American Regionalist painters. In the six years that followed, Nicosia would continue

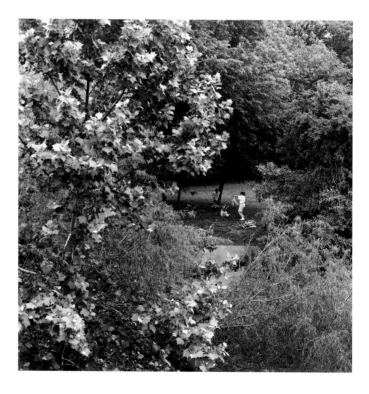

46 fig. 22 Nic Nicosia, *Untitled,* 1979, chromogenic photograph, 12¾ x 19 inches. Courtesy the artist, Dunn & Brown Contemporary, Dallas; P•P•O•W, New York; and Texas Gallery, Houston

fig. 23 Nic Nicosia, *Real Pictures #14,* 1989, silver gelatin photograph, 48 x 48 inches. Courtesy the artist, Dunn & Brown Contemporary, Dallas; P•P•O•W, New York; and Texas Gallery, Houston

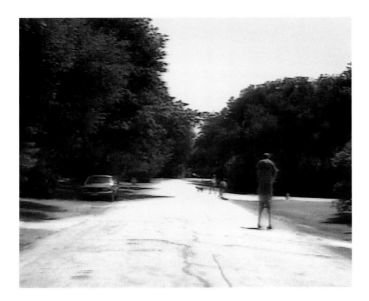

ramp, which, we all hope, will propel him safely over them. The exploits of these children are clearly typical occurrences that, for better or worse, are part of growing up. But in many ways the neighborhood is also a microcosm, and Nicosia makes it his stage for allegories echoing the adult power plays and personal manipulation found in business and society.

Nicosia's exploration of the clichés and realities of suburbia finds deeper, stronger form in the videos and films produced since 1997. In particular, the fifteen-minute video *Middletown* (1997, fig. 24, pls. 37–44) traces the loops and lanes of a seemingly typical neighborhood on a lazy summer day. It is a reunion of characters from earlier Nicosia's still images: kids who ride bikes, play in the street, or attend a birthday party as well as their property-conscious parents, including another lawn-waterer, a gardener (in a bathing suit and big floppy hat), and two lawn mowers, one a machine at rest and the other a man working in his office clothes. The props are carefully selected, from the predictable vans and sport utility vehicles favored by "soccer moms" and the Radio Flyer wagons loved by kids, to the unexpected—an inflatable plastic sex doll dragged by a boy on a bicycle or the briefcases carried by two tall cowboys in suits, a nod to characters broadcast into stereotypes by the television show *Dallas*. Yet the video format allows Nicosia to express so much more than the single still images. He stretches out time, carefully pacing the introduction and reappearance of each character or event along our path or at each turn in the road. With music that adds an eerie edge by suggesting either the whimsy of a merry-go-round or a sinister David Lynch movie soundtrack, Nicosia sets a tone that runs counter to the neighborhood's apparent tranquility.

The Family

Family life, with its complicated dynamics and dramas is another thread that weaves through Nicosia's oeuvre. The diverse ways that parents and their children relate to each other (and how they don't) have been an ongoing focus of this artist, whose own children were born in the years when he was making his first few series (they are now in college).

Several pictures were formally inspired by his daughters' early activity books. Nicosia was attracted by the oversimplified outlines found in coloring books for two-year-olds, with their flattened silhouette forms and dizzying patterns rendered in a highly distorted perspective, a contrast to the richly detailed information that a photograph offers. In *Coloring Book, page 2* (1981, fig. 25), a freehand cutout drawing of a giant couch, with accompanying table and lamp, has been pasted onto one studio wall, while the perpendicular one carries a similar drawing of a television. Although a child lies prone before the TV set in a too-typical family situation, the rudimentary foreshortening and a contorted, off-angle checkerboard floor disrupt the normalcy of the scene.

A more complicated family scenario is setup in *Domestic Drama #1* (1982, pl. 4). While the parents are otherwise occupied, tucked away in "his and hers" bathrooms, engaged in their morning rituals, their daughter is scribbling energetically—not in her coloring book, but *on the wall*. The scattered array of props and painted details make this (studio) house into a family home. Clothes, dolls, and stuffed animals are strewn about; out of the painted cardboard dresser drawer hangs a pair of panties, tucked into the frame of a hand-drawn mirror are hand-drawn wedding photos; a stream of toilet paper flows from his bathroom; and a fallen bottle of talcum powder litters hers—all adding witty dashes of domestic (if pointedly faked) realism.

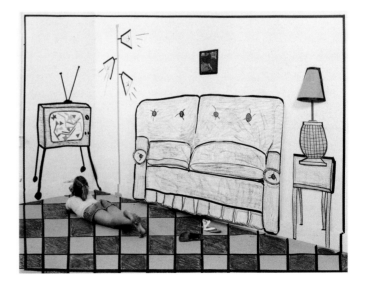

fig. 24　Nic Nicosia, still from *Middletown*, 1997, digital video. Courtesy the artist, Dunn & Brown Contemporary, Dallas; P·P·O·W, New York; and Texas Gallery, Houston

fig. 25　Nic Nicosia, *Coloring Book, page 2*, 1981, chromogenic photograph, 30 x 40 inches. Courtesy the artist, Dunn & Brown Contemporary, Dallas; P·P·O·W, New York; and Texas Gallery, Houston

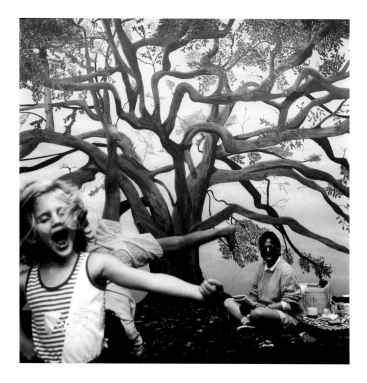

Seventeen years later, Nicosia would return to this hectic morning moment in his film *Middletown Morning* (1999, cover, fig. 32, pls. 49-54), his most recent work. In the short, quickly-paced film, a father, played by the artist, gets the newspapers from the front patio (one must be fished from the fountain), yells at the paperboys, tends to a crying baby, and answers two phone calls (one a wrong number, one from his dealer), all the while trading the baby back and forth with his wife, before dashing out the door to work. As they go through the paces of this domestic obstacle course, the ambitious contemporary couple takes all the human, mechanical, and electronic interruptions and glitches in stride as if they were part of every day's routine.

Despite the gray weather, the photograph *Vacation* (1986, fig. 26) is enlivened by the joy of two playful girls, one turning a cart-wheel and another dancing gleefully before the camera. Off to the side, mom (costumed in a sweater, sunglasses, and a kerchief) is seated next to the remains of a picnic, looking up from her reading to check up on them. On the backdrop behind them, Nicosia has painted a big, old tree with wide, branching limbs, just the kind kids love to climb or build treehouses in. Only later, through the foliage do we notice a plane crossing the gray sky in flames, a prediction of the tension—and more complicated themes—to come in Nicosia's subsequent series.

The "Real Pictures" series deals less with families than with children and adults acting on their own, but in the 1991–93 "Untitled" series, we find family situations that are much more psychologically involved than those earlier visions of the morning rituals of harried parents or moms enjoying their children at play. We've moved from daylight to after dark, in both time and tone. For example, in *Untitled #2* (1991, pl. 30), the father is seen in silhouette sitting sternly upright with his coffee, while at his feet one daughter is trying on a pile of mom's high heel shoes. In the background, another younger daughter, also playing dress-up, is intensely scrutinizing her own image in a hand mirror, surrounded by a table full of childhood family portraits. Though just a minor detail, these photos suggest a dream of earlier innocence, less complicated games, and more easily defined family relationships, pushing to the foreground questions about the ways families shape individual identity. In *Untitled #6* (1992, pl. 26), a spotlit daughter in a ballerina's tutu stands on the dining room table. Her pose is one of purity and innocence, but on her face we see a hint of the self-consciousness that comes with adolescence and emerging sexuality. In the shadows behind her, the two parents watch, as if from the wings of a theatre, the mother even mimicking the dance position as if in unconscious support. They are solemn, perhaps stunned by the realization that their daughter will all too soon leave their domestic stage for society's wider world. At the time Nicosia created this series, he also was busy with commissioned portraits of individuals and families that he feels influenced images such as these. The artist explained, "I was going into many different domestic situations, and it provided fodder for a lot of this work."*

The Couple

The male-female relationship has also been subjected to Nicosia's special blend of sarcasm and sensitivity. His representations of couples started out flat, almost cartoon-like, as in *Domestic Drama #2* (1982, fig. 27). This split-screen scenario pictures a wife eyeing the proverbial TV repairman on one side, while the husband pursues the office secretary on the other. In *Domestic Drama #3* (1982, pl. 5), a couple is caught in the middle of an emotional argument, perhaps a territorial dispute about the details of the house that is being built around them. They literally stand on the floor plan, while around them the architect works on more drawings, the bricklayer takes a break from his work, a painter climbs a ladder, and as a sad detail, their daughter silently witnesses the whole dispute.

As its name implies, the 1990–91 "Love + Lust" series features more complex emotional encounters and liaisons, often implicating the viewer in the scene. We are swept with an illicit feeling of voyeurism as we view *Love + Lust #1* (1990, fig. 21), which is composed as if we were looking through a hole in the neighbor's fence. All eyes are upon a young woman posed in unfettered pleasure, her head tipped back, a wide smile on her face, and her

fig. 26 Nic Nicosia, *Vacation*, 1986, silver dye bleach photograph, 48 x 48 inches. Collection Dallas Museum of Art, The Karl and Esther Hoblitzelle Collection, Gift of the Hoblitzelle Foundation

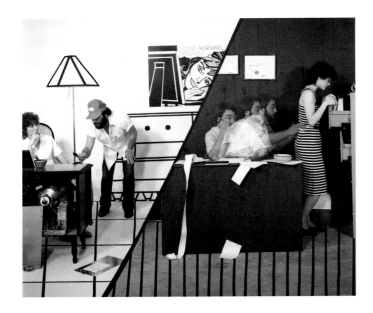

bikini top slipping off her shoulders. Off to the side, a man (no, he's not that apparent at first) enjoys the spectacle, though it seems clear that *she* is in charge of the pleasure for them both. Since the 1970s feminist art and theory have added greatly to how we look at and think about images by, of, or for women, but Nicosia feels that he has been more influenced by experience and observation. "I'm around women a lot: I'm married to one, I have two daughters, and I take lots of portraits of them. I've noticed that women have a psychological advantage over us; even the little girls control their image, themselves, and the men around them."

The "male gaze," and its traditional power over the representation of women as submissive objects, is a common subject of contemporary feminist critique. Rather than show the man leering at the woman, Nicosia neatly turns the tables, as well as the privilege of the observer, in *Love + Lust #14* (1990, pl. 24). Set in an elegant, well-appointed home, two women stare down appraisingly at a man stripped naked for their inspection. While empowering the women by letting them ogle the hapless man, the image also cuts to the core of the vulnerability of the male ego and the symbolic power of the phallus, fusing them directly with a deeply rooted sexual anxiety—making men cringe or at least chuckle nervously.

The emotional distance and alienation that sometimes force apart a relationship are the subject of both *Love + Lust #6* (1990, pl. 25) and *Untitled #5* (1991, pl. 31). In *Love + Lust #6*, a couple in bed is clearly stuck at a communication impasse, perhaps after a quarrel. She sits up, still visibly agitated, and looks down at him, but he has turned away, wrapping himself in the bedding as if to seek emotional insulation. Shot from his side of the bed, we are allowed access to his distanced sentiment, signals that he

withholds from his wife. In *Untitled #5*, a different couple has finished dinner and sits quietly, each lost in private diversions: he is reading and she is fixing her hair in the reflection of a dinner knife. In the backyard behind them, viewed through the window, is a perfect little child's playhouse, illuminated brightly so as to loom large as a haunting symbol of the impossibly "ideal" relationship.

The Individual

Nicosia is a keen social observer, skilled at capturing essential encounters between friends, families, and lovers. But he can also reveal much about the solitary individual, drawing upon life experiences and observations from his practice as a portrait photographer. A number of key images show figures alone, whether independent by choice, isolated by self-reflection, or excluded by others.

In *Youth* (1986, fig. 28), a young man gleefully steers his motorcycle into the sunset. Dressed in a loose T-shirt and baggy Hawaiian-print shorts, he pilots the escape vehicle lying flat, his body fully paralleling its forward motion, oblivious even to his riding companions on another cycle, who are lost in a daring kiss. "When I made this picture," the artist recalled, "it was a time of many violent disasters in the news, like the Challenger explosion and buses being blown up by terrorists. I wanted to show that optimistic, invincible death-defying attitude of a sixteen-year old guy who is not paying real attention to what's ahead." Although the scene was staged in a studio, it is shot as if from a passing vehicle (note the side view mirror at the lower left). Nicosia brings us up alongside this deliberate act of youthful thrill-seeking, giving us a taste of both the pleasure and the risk.

She may be as independent as the young rebel above, but *Ms. D'Avignon* (1985, pl. 12) seems quite settled in her life. She poses nobly, wearing heavy jewelry and heavy makeup, with an expression

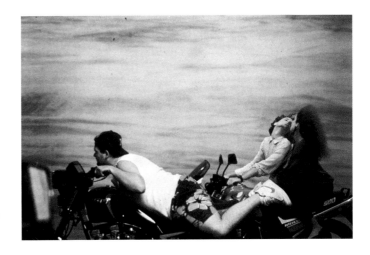

fig. 27 Nic Nicosia, *Domestic Drama #2*, 1982, chromogenic photograph, 30 x 40 inches. Collection Dallas Museum of Art, Gift of Steve Dennie and Debra Joy Allen

fig. 28 Nic Nicosia, *Youth*, 1986, silver dye bleach photograph, 48 x 72 inches. Collection Dallas Museum of Art, The Karl and Esther Hoblitzelle Collection, Gift of the Hoblitzelle Foundation

of reticent pride. The single chair, of an impressive Louis XVI style, reiterates her solitary status. A pair of fancy ornamental mirrors, treasures from days gone by, frame only tattered silvering, their ability to reflect beauty all but eroded. Long, sidewise shadows from a window projected onto the back wall suggest the onset of twilight and the winding down of a life fully lived.

Nicosia's five-minute film *Moving Picture* (1998, pls. 45–48) shows how the inhabitants of one household are like molecules in constant motion, independent individuals on their own paths who are marching to their own drumbeats, each playing his or her own games. Like a guest, we follow the camera in from outside and meander through the house, catching only glimpses of its residents as they crisscross the common areas or open doors into private spaces. Only in the end do they gather, congenially, in the dining room for a meal. Nicosia shows this family, like most are today, more as independent entities than as a group with shared interests and common bonds.

Although togetherness is the goal, the emotions of love and lust—as well as desire, longing, and other associated pangs—are experienced first by individuals. Sometimes one partner may fulfill his or her own personal needs or enjoy a simple pleasure because the other is asleep (or worse, just not paying attention). In the bedroom scene of *Love + Lust #11* (1990, pl. 21), a half-dressed woman stands over a small fan, her skirt raised by the gust. Hands relaxed by her side, eyes closed, her head tipped back, she is enjoying a cool moment of breezy private reverie while on the bed nearby a man's legs point to a presence oblivious to—and now unnecessary for—her enjoyment. *Love + Lust #13* (1990, pl. 22) captures a similar moment of private pleasure: a young man caught with his pants down is unknowingly viewed through a closet door. His body language spells out the shame he feels about his furtive action. On the wall next to him is a photograph of two young parents peering down, as if into a crib at their newborn baby. Independence, emotional maturity, and the discovery of one's sexual feelings, are all parts of growing up from which Nicosia doesn't shy away. Throughout the "Love + Lust" series, he taps into a wide range of sexual expressions and responses.

Moving away from early caricatures such as *Bill and Pete*, Nicosia has gradually drilled deeper into the male psyche. One powerful image is *Untitled #3* (1991, pl. 27), shot at night in a backyard patio. The single male figure, in late middle age, smoking a cigar, lifts a barbell with one arm while pushing against a post with the other. Despite the pleasant surroundings, hints of instability and nagging insecurities are planted within the image. Why is he alone at this hour of the night? The house of cards, built tenuously close to the edge of a glass table and spotlit at the foreground of the image, is an icon of instability and isolation. As a consolation for his heavy eyeglasses, receding hairline, and aging body, Nicosia gives him the comfort (and masculine

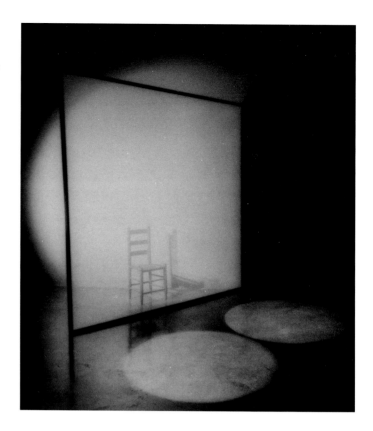

symbolism) of a long cigar and some barbells to signal his resolve to resist further physical decline. Still, his body language reveals that in his mind he has slipped out of this moment, perhaps to past happier times or maybe towards a vision of the future—brighter or bleaker.

In Nicosia's "Acts 1–9" series many more solitary figures take the stage. Some works, such as *Act 4* and *Act 7* (fig. 34), both 1994, isolate elegantly staged gestures that draw upon theatrical conventions but also raise questions about the presentation of the self in everyday life. In *Act 4*, a nude female figure in a circular spotlight poses with arms spread wide, as if both to find balance and to offer herself to the gaze of the audience, represented by (empty) seats. Her face, expressionless, is painted white like a mime, her eyes cast downward as if to deny a direct expression of individuality. The staging is equally dramatic in *Act 7*, but again all emotion is withheld. Against a frame of bright light bulbs, a tuxedoed male figure bows, a common enough gesture, yet in the context of this series it could be read as submission to the viewer—or protection of the private self. In *Act 2* (1994, fig. 29), Nicosia again addresses solitary existence, using the set, props, and lighting alone to make his metaphor. A single, empty chair is positioned behind a scrim glowing in bright light, while the space before the transparent wall is dark but for the illumination of two single spotlights, a gentle picture of companionship now gone.

fig. 29 Nic Nicosia, *Act 2,* 1994, silver gelatin photograph with oil tint, 56 x 49 inches. Collection Lisa and Charles Brown, Dallas

As with *Ms. D'Avignon* we find a two-to-one opposition (like her single chair and the pair of mirrors), but here the scene is anonymous, making it even more poignant.

One of the most powerful images of this haunting series is *Act 9* (1994, pl. 35) in which Nicosia has transformed himself with makeup into a much older man. His body is bulked up by a pillow, he is dressed in a stodgy suit and out-of-style necktie, and his balance is wobbly as he clutches a cane. By enacting this perverse fantasy of future decline, Nicosia confronts the inevitability of aging. While over the years Nicosia has directed many others in his dramas about the ups and downs of life, the artist himself appears only occasionally. Now, he steps forward to play the difficult role of himself, a few decades from now, to remind us all that as we walk forward, we, too, will grow weaker, less sure of ourselves, and more alone.

Too close for comfort: trouble in paradise

One of the final works in the exhibition, the video projection *So…You Wanna Be an Artist* (1997, pl. 36), provides caustic commentary on the complications of making serious art today. In this short, simple video, an elegant male figure enters the spotlight, snidely sneers the sentence in the title, then, for the remaining half minute, laughs contemptuously at the idea that anyone can be an artist. Then the piece recycles and begins its disdainful repertoire again. Shot in the theatrical chiaroscuro of the "Acts 1–9" photographs, the character—and that sinister, cynical laugh—confounds us with his conflation of an elevated visual elegance and derisive tone. The bitter ridicule is probably not intended for today's young artist-to-be, but instead should be seen as self-referential, dismissing Nicosia's own initial naïveté, while underscoring his mature acknowledgment of the real challenge to making significant art today. Embarking on a career as a photographer with little art education and less art world experience, Nicosia was lucky that his fresh and funky experiments, bringing together ideas from photography, painting, and film immediately attracted international attention. His handcrafted tableaux about the daily domestic dramas of young parents or the silly social scenes that had a trustee punching the local museum director, among other gags, warmed crowds with their inventiveness and playful charm.

But for Nicosia and many others, the final few years of the 1980s meant more than the end of the art boom and, locally, the onset of a recession caused by the declining Texas oil market. The art world experienced a major paradigm shift—which we are still trying to understand—away from splashy, colorful egos, witty ironies, and theoretical posturing towards an art with more sincere and passionate human content and emotional contact.

A comparable change occurs with Nicosia's 1987–89 "Real Pictures" series and subsequent work, which begin to plumb the complications of the human soul. It was as if Nicosia made some Mephistophelean deal—perhaps with that elusive guy with the spiteful laugh or just with himself—to up the ante, to get closer to the fire, to pursue the bigger mysteries. Hurled through the studio wall into the rough real world, Nicosia could see—and for a decade has been revealing for us—a millennial uneasiness lurking in the shadows.

Nicosia's best work of the past ten years gets under the skin, sometimes with brash violence, sometimes with quiet, potent enigma. Through his carefully staged scenes, he illuminates truths about the human condition in America at the end of the century that are often too close for comfort. For example, in *Real Pictures #8* (1988, pl. 18), a fight breaks out between a man in a car and a clown headed for a birthday party. We view the scene from a second floor window across the street, purposefully cut off from the specifics of the altercation, but with a clear enough view of the bottle-wielding car passenger and the lunging clown who flips him the finger to become deeply troubled by this public display of hostility. And it is not just the breakdown of social graces that Nicosia submits us to: even the tension between humanity and nature is brought forward. Another classic image is *Real Pictures #11* (1989, page 3) in which three kids are mesmerized as flames engulf a small tree (barely taller than they are) that they have casually doused with gasoline and set ablaze. The girl glances over her shoulder, her eyes betraying both apprehensive guilt and lost innocence. Nature's revenge comes in the lunging pit bull of *Real Pictures #10* (1988, pl. 19), which leaps out at us unexpectedly, the windshield providing little emotional protection.

This survey exhibition allows us to see the richness of Nicosia's creativity, the dexterity of his imagination, the sharpness of his eye for detail, and the intensity of his understanding of a full range of human emotions. Over the past two decades, Nicosia has focused on suburbia, the family, the couple, and the individual, always sharpening the edge. He continues today to produce powerful works that reveal new insights into the fun, foibles, and festering wounds of American culture.

*Nic Nicosia, telephone conversation with the author, July 8, 1999.
All other quotes are from this conversation.

Real Pictures

1987–89

Okay, so with *Life As We Know It*, I failed at steering the audience into the content instead of the fabrication. They liked the music, though. But, people still asked questions like who the actors were, what did I paint, what did I build? They looked for the humor as it had been prominent in the previous work. I would see them laughing as if what they were looking at was funny. I'm thinking, "Hey! There's a dead guy there! There's a plane crashing! What about that?!"

So, I decided to eliminate the color and shoot outside the studio, on location. Although the action was still made up, it looked real, and the audience finally began to deal with the content. I guess we believe in black-and-white pictures.

The locations were in the suburbs and, for most of the pictures, I used kids to create and explore a kind of benign children's violence. Suburban stuff. *Real Pictures* #6 (page 2) with the floating body was shot at a place where I used to hang out as a kid in Dallas. I can still remember my fear of climbing up that cliff. People have fallen and died there. In fact, someone died right before I was going to make this picture. I postponed the shoot.

—*N.N.*

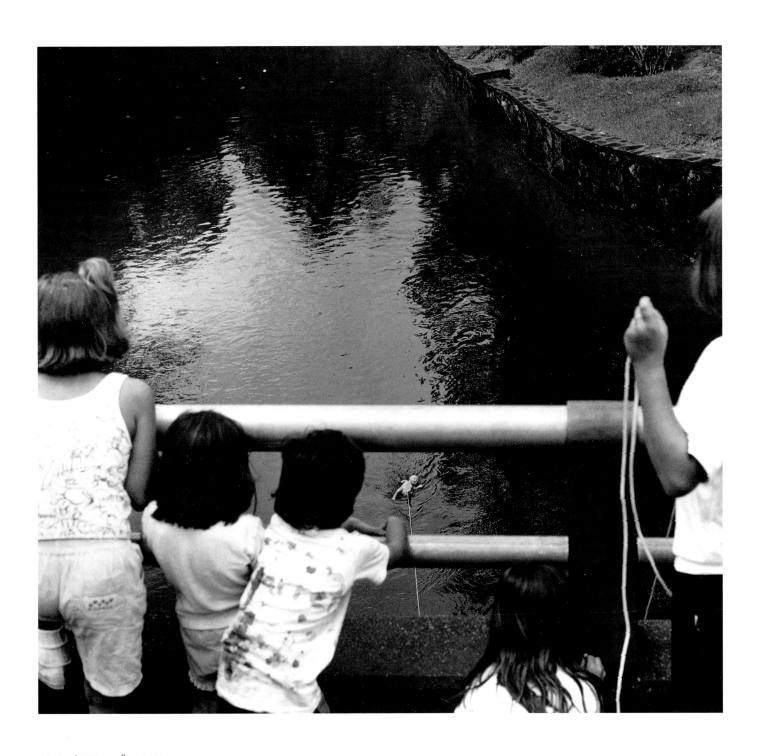

16. **Real Pictures #15**, 1989
Silver gelatin photograph
48 x 50 inches
Courtesy the artist, Dunn & Brown Contemporary, Dallas;
P•P•O•W, New York; and Texas Gallery, Houston

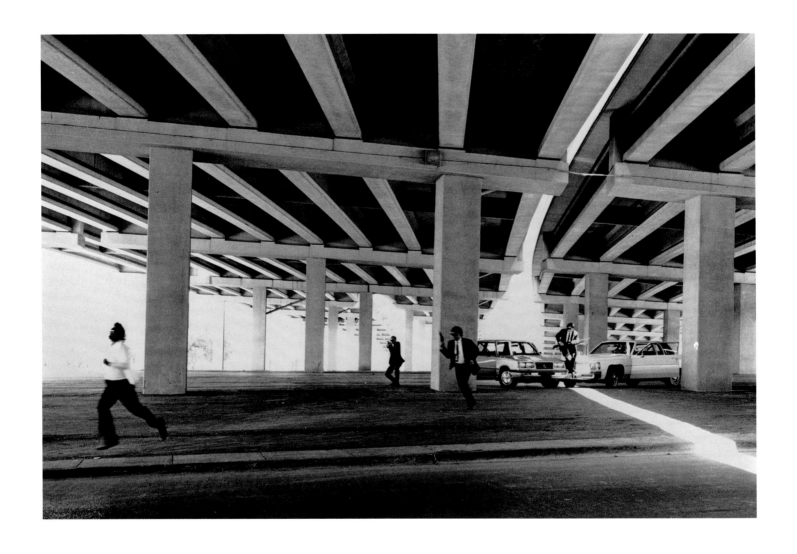

17. **Real Pictures #2**, 1987
Silver gelatin photograph
48 x 72 inches
Collection Cece Smith and John Ford Lacy, Dallas

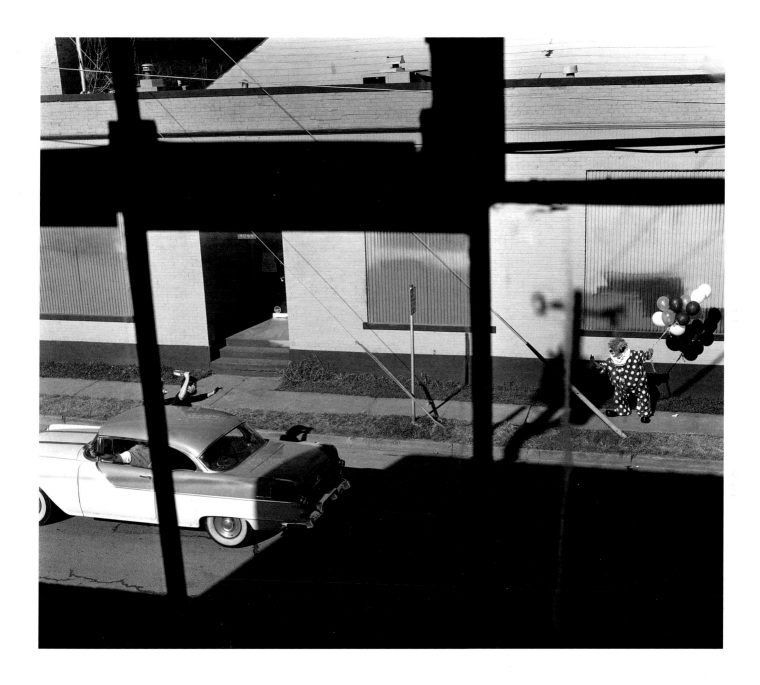

18. **Real Pictures #8**, 1988
Silver gelatin photograph
48 x 52 inches
Collection Eileen and Peter Norton, Santa Monica

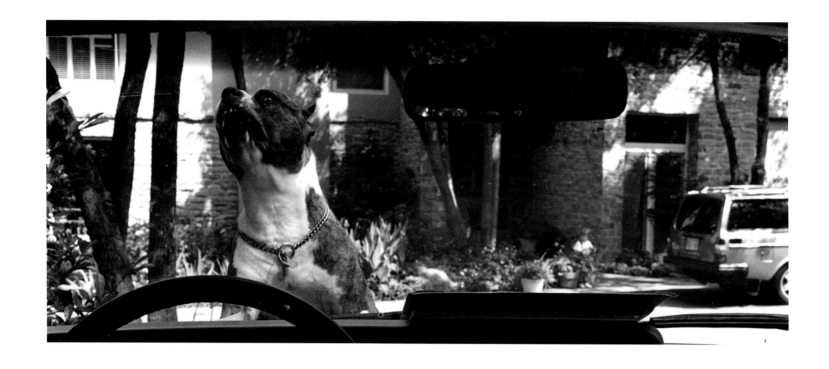

19. **Real Pictures #10**, 1988
Silver gelatin photograph
36 x 84 inches
Courtesy the artist, Dunn & Brown Contemporary, Dallas;
P•P•O•W, New York; and Texas Gallery, Houston

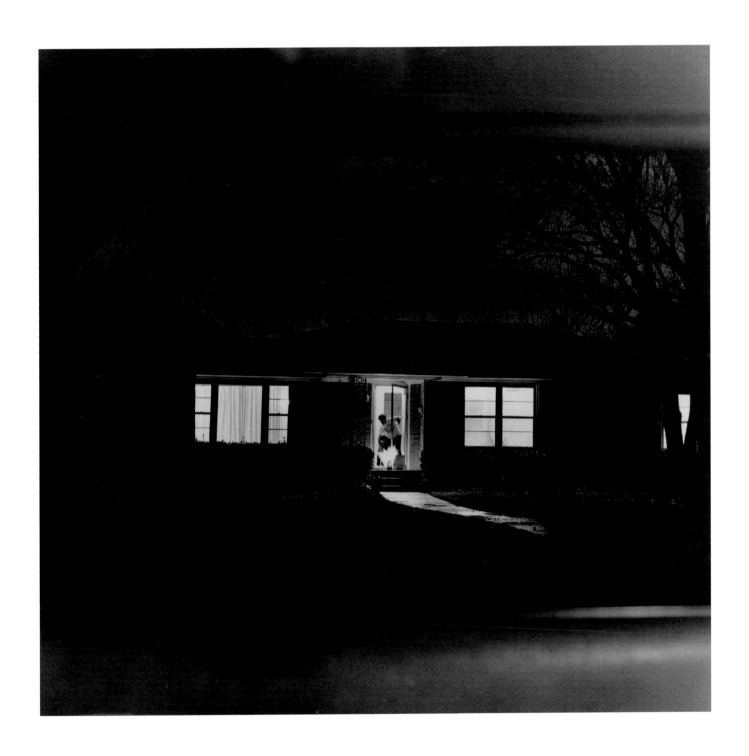

20. **Real Pictures #19**, 1989
Silver gelatin photograph
48 x 48 inches
Courtesy the artist, Dunn & Brown Contemporary, Dallas;
P•P•O•W, New York; and Texas Gallery, Houston

Love + Lust

1990–91

Love + Lust

I had been working on "Real Pictures" for three years and most of
the subject matter dealt with kids. I was ready to deal with adult
information and adult actors.

 When it gets down to it, lust is way more fun than love. Be-
sides, if you set out to make pictures of love (I'm talking about
with people), you usually can't avoid showing lust. Or you'll end
up making greeting cards with little hearts and cupids.

<div align="right">—N.N.</div>

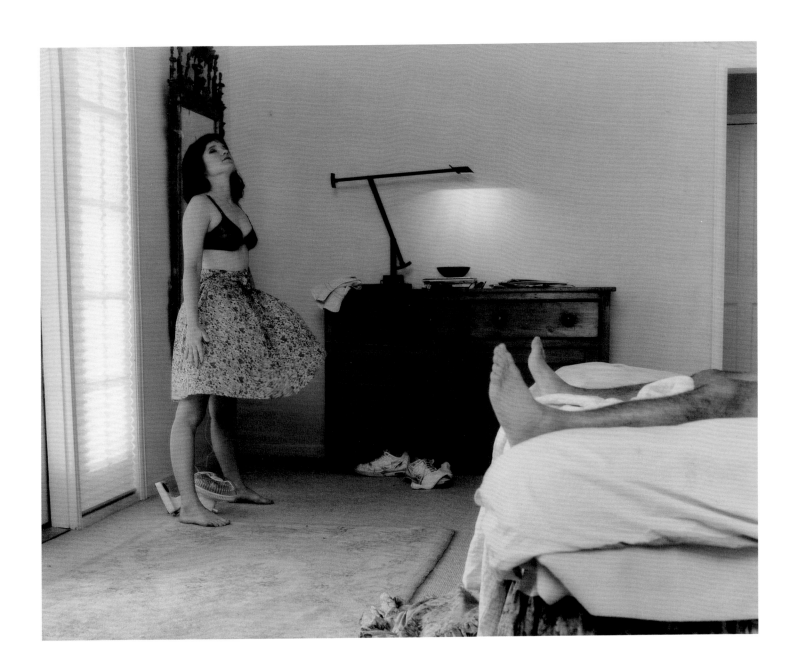

21. **Love + Lust #11**, 1990
Silver gelatin photograph with oil tint
30 x 37 inches
Collection New Orleans Museum of Art: Gift of Nic Nicosia,
Linda Cathcart Gallery, and Texas Gallery

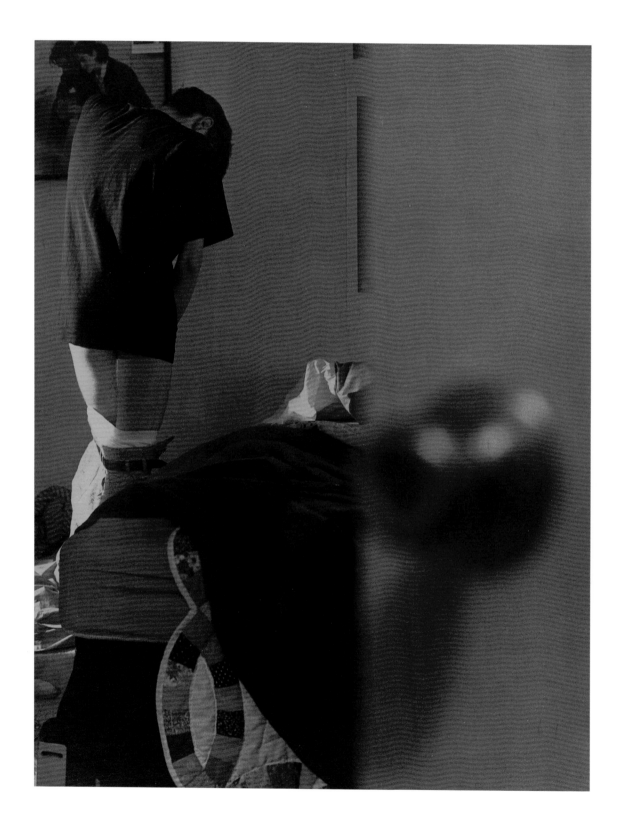

opposite:
22. **Love + Lust #13**, 1990
Silver gelatin photograph with oil tint
30 x 24 inches
Courtesy the artist, Dunn & Brown Contemporary, Dallas;
P•P•O•W, New York; and Texas Gallery, Houston

23. **Love + Lust #8**, 1990
Silver gelatin photograph with oil tint
30 x 43 inches
Collection John and Susie Kalil, Houston

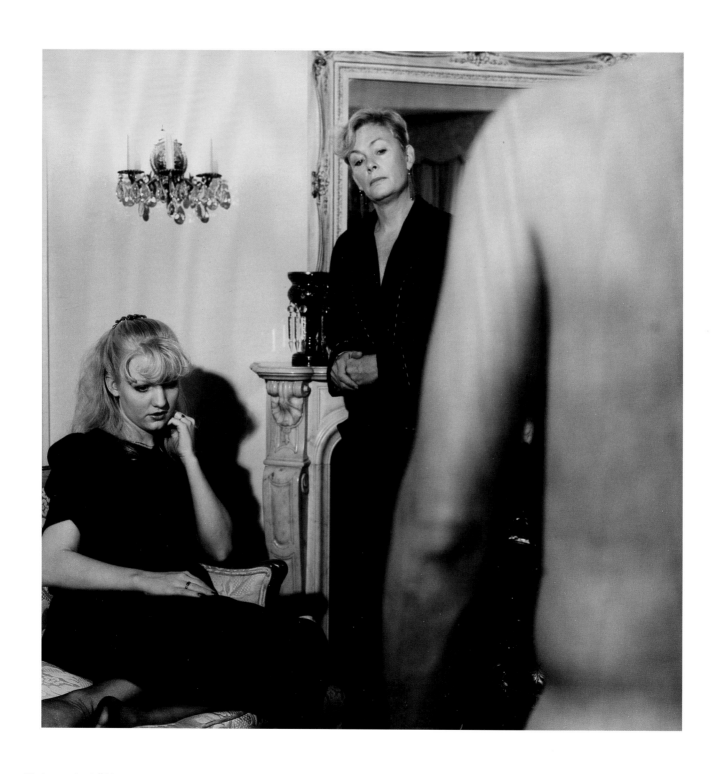

24. **Love + Lust #14**, 1990
Silver gelatin photograph with oil tint
30 x 30 inches
Collection Mr. and Mrs. Stephen Susman, Houston

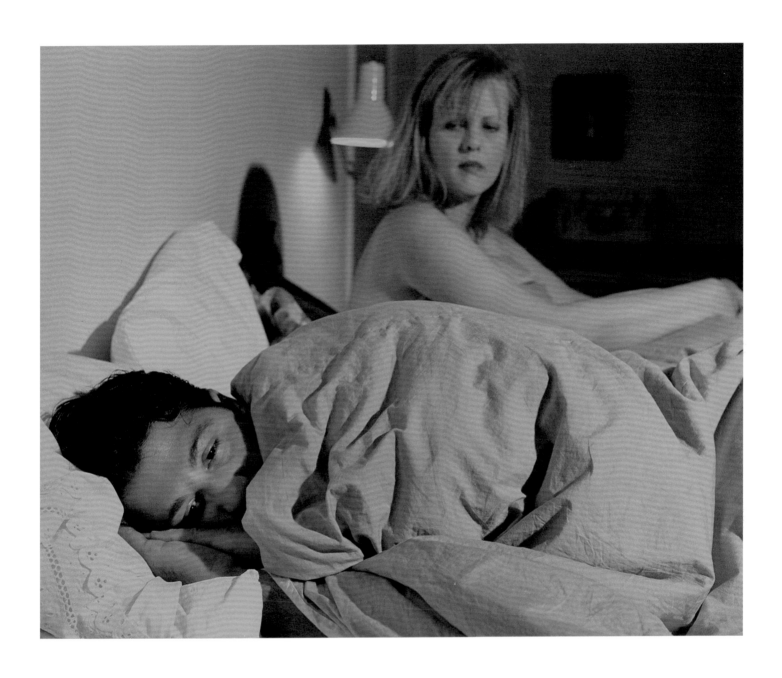

25. **Love + Lust #6**, 1990
Silver gelatin photograph with oil tint
30 x 36 inches
Courtesy the artist, Dunn & Brown Contemporary, Dallas;
P•P•O•W, New York; and Texas Gallery, Houston

Untitled

1991–93

I had started to accept private portrait commissions and it began to take a toll on my time and the time to make art. It caused me to question my validity, and I wanted a bit of time to relax (I don't really know how to relax, but I wanted to anyhow). For the most part, the images came intuitively—unplanned. Then, I didn't know when to stop; I always knew that before.

With this series, the psychological mood created by lighting became very important. The pictures were shot at night in order to have easier control of the lighting and, well, because the night equates relaxation with me.

What I wished to do with "Untitled," as with "Real Pictures," was to present an image and then allow the audience to interpret it based on their individual experiences and life lessons.

—*N.N.*

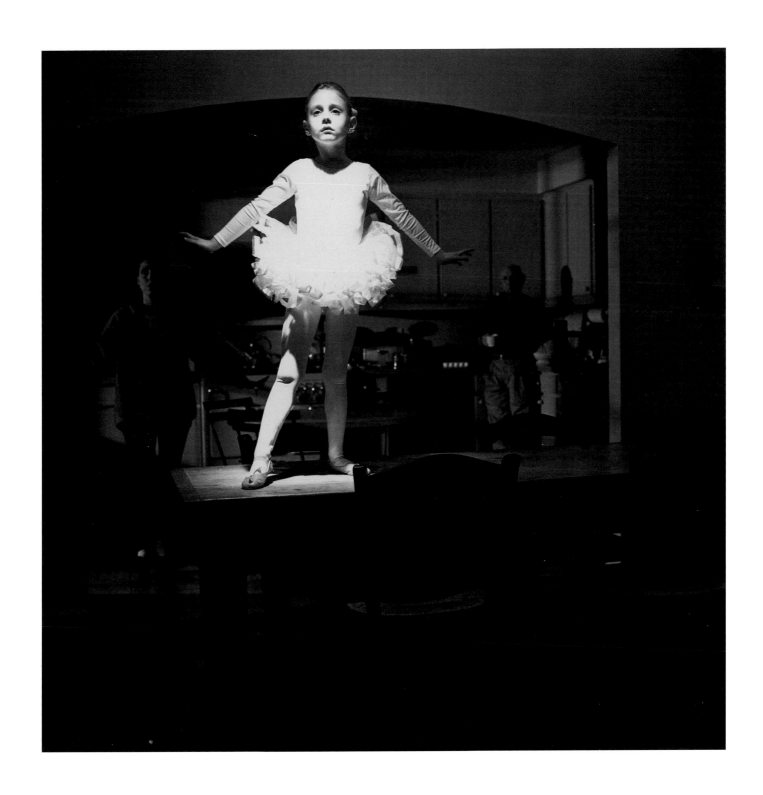

26. **Untitled #6**, 1992
Silver gelatin photograph with oil tint
36 x 36 inches
Collection Deborah Brochstein, Houston

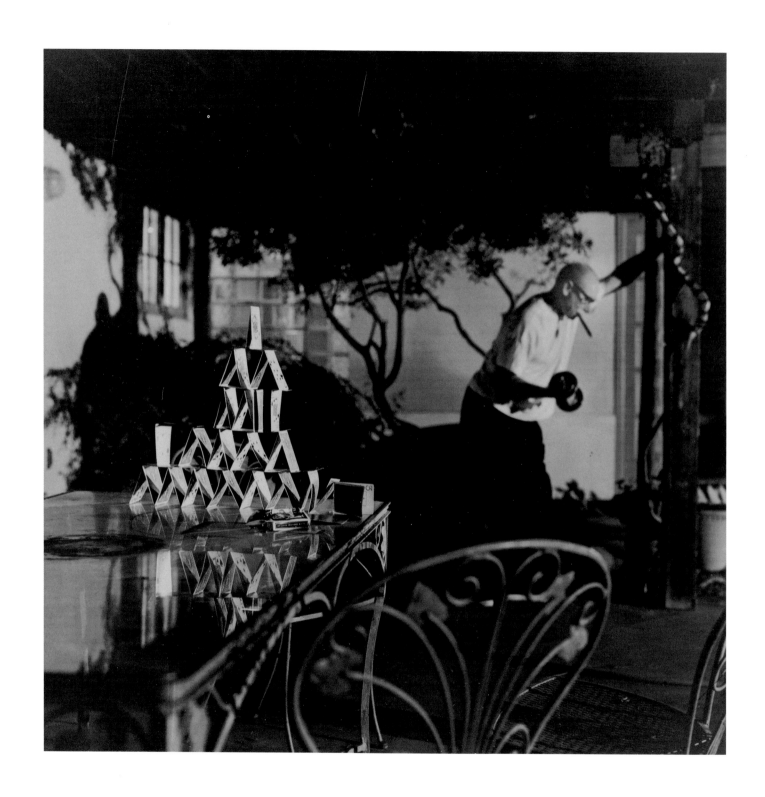

27. **Untitled #3**, 1991
Silver gelatin photograph with oil tint
36 x 36 inches
Collection Jeanne and Michael Klein, Houston

28. **Untitled #4**, 1992
Silver gelatin photograph with oil tint
36 x 36 inches
Collection William Lincoln, Fort Worth

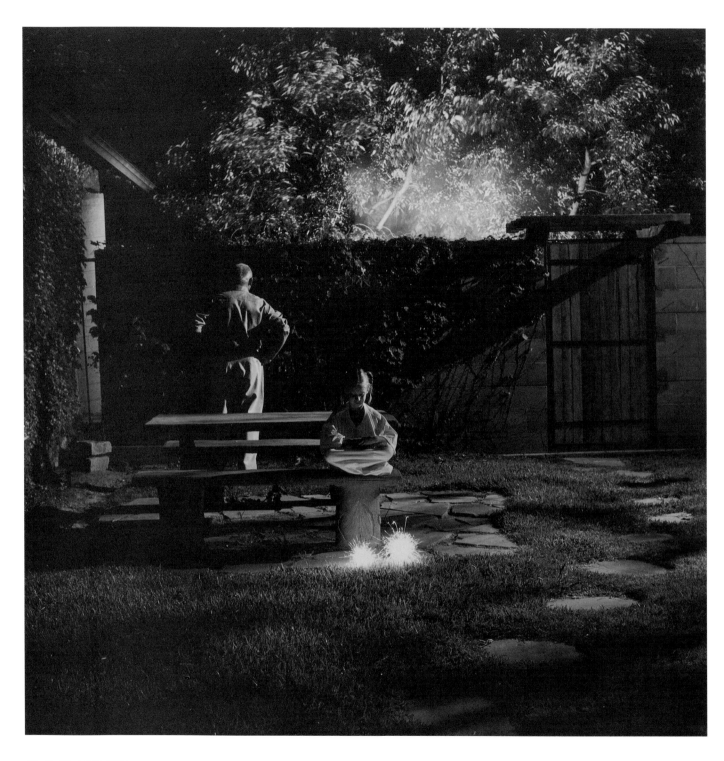

29. **Untitled #10**, 1992
Silver gelatin photograph with oil tint
36 x 36 inches
Collection of the Modern Art Museum of Fort Worth, Museum Purchase,
made possible by a grant from The Burnett Foundation

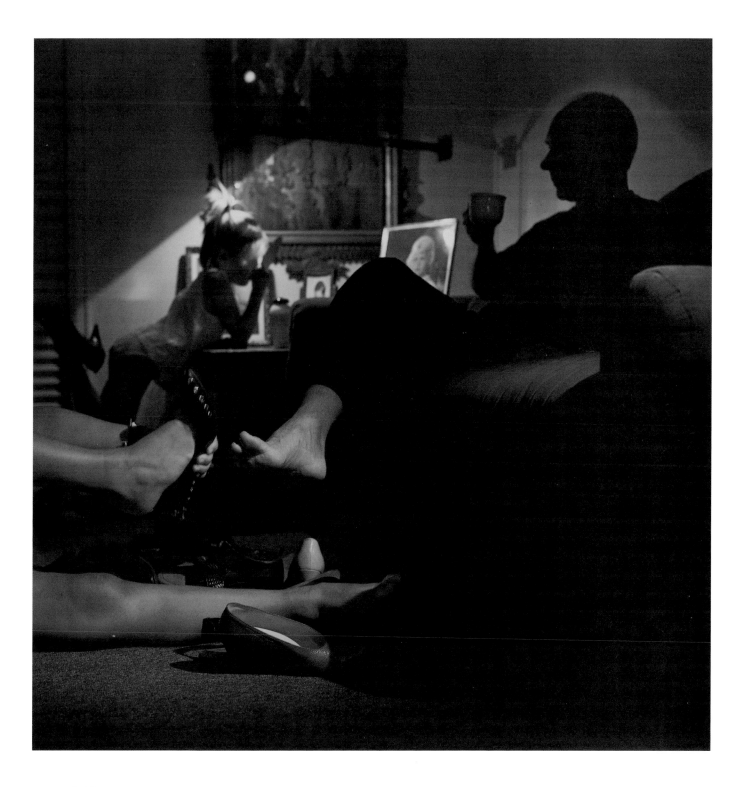

30. **Untitled #2**, 1991
Silver gelatin photograph with oil tint
36 x 36 inches
Courtesy Gerald Peters Gallery, Dallas

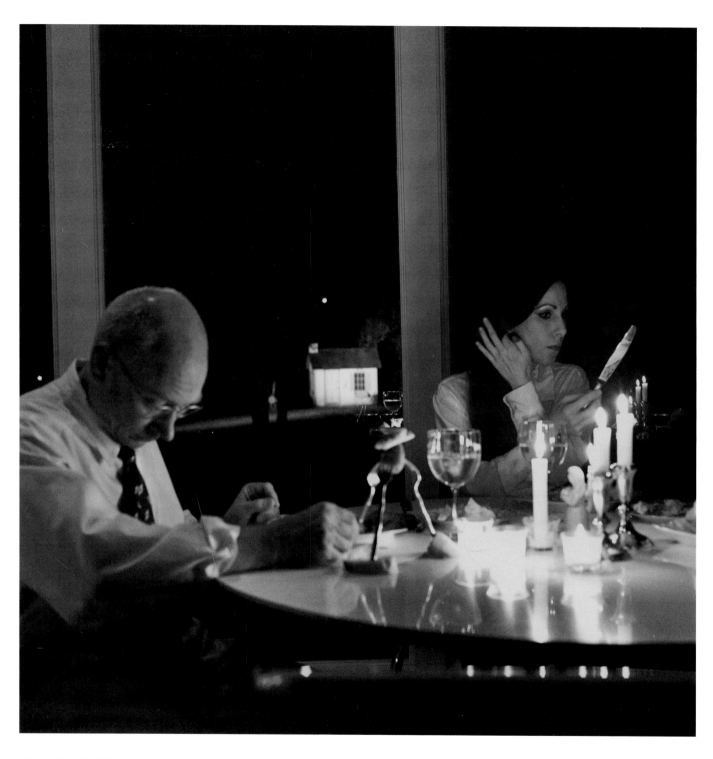

31. **Untitled #5**, 1991
Silver gelatin photograph with oil tint
36 x 36 inches
Courtesy the artist, Dunn & Brown Contemporary, Dallas;
P•P•O•W, New York; and Texas Gallery, Houston

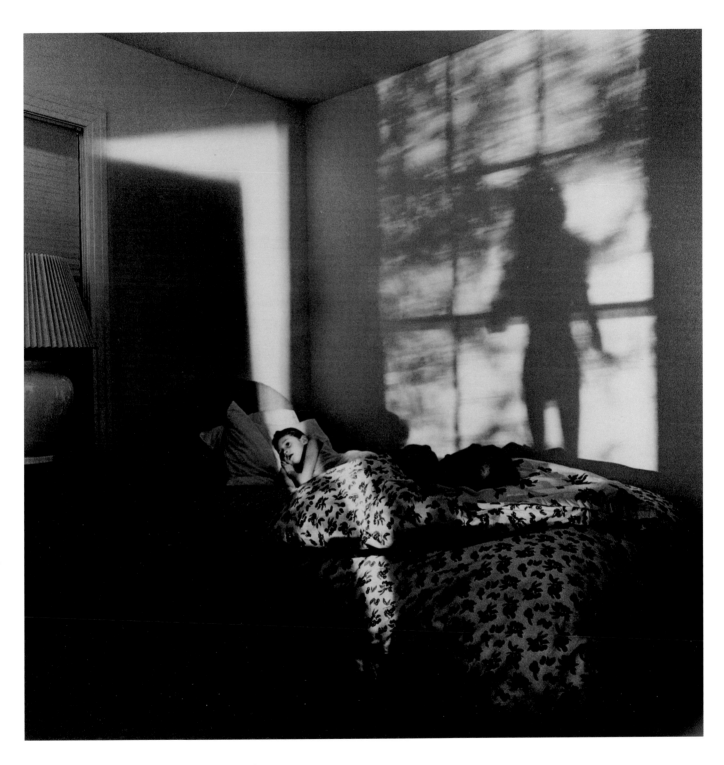

32. **Untitled #7**, 1992
Silver gelatin photograph with oil tint
36 x 36 inches
Collection of the Modern Art Museum of Fort Worth, Museum Purchase,
made possible by a grant from The Burnett Foundation

Acts 1–9

1994–95

This is good. I'm back in the studio. I'm in control again. I'm working without location headaches, on my own time. I'm thinking "Hey, I'm basically a minimalist, so I'll make minimal pictures!" I didn't want them to appear staged as in the early work; I still wanted to convey a sense of realism. Think of this work as a group of theatrical stills.

But more so, it wasn't that I just wished to change my work by returning to the studio—I was growing weary of making still images. I was searching. There was no challenge, no reward, I was losing the passion for it and I really need the passion. Nonetheless, I love these images; I have never grown tired of looking at them or thinking about what they represent.

For *Act 9* (pl. 35), I wanted to be the guy getting the make-up. I wanted to see what that was like. The old-age make-up alone took 2½ hours and once it was on, I "became" the character. I became crotchety, my voice started rattling and I began to stoop over. This man is facing an audience, talking to someone, maybe about his life story. Maybe this is a play and he is delivering his monologue. Some say he reminds them of Willy Loman from *Death of a Salesman.*

—N.N.

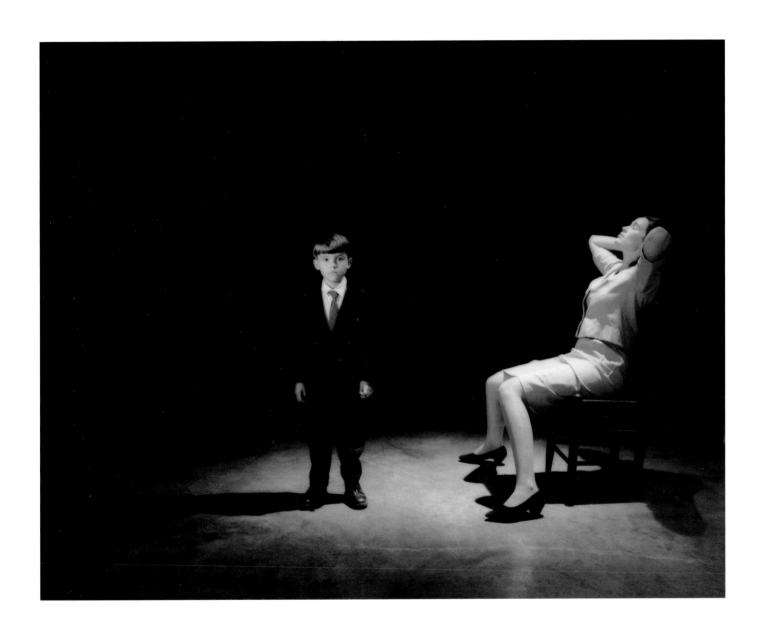

33. **Act 4**, 1994
Silver gelatin photograph with oil tint
49 x 62 inches
Courtesy the artist, Dunn & Brown Contemporary, Dallas;
P•P•O•W, New York; and Texas Gallery, Houston

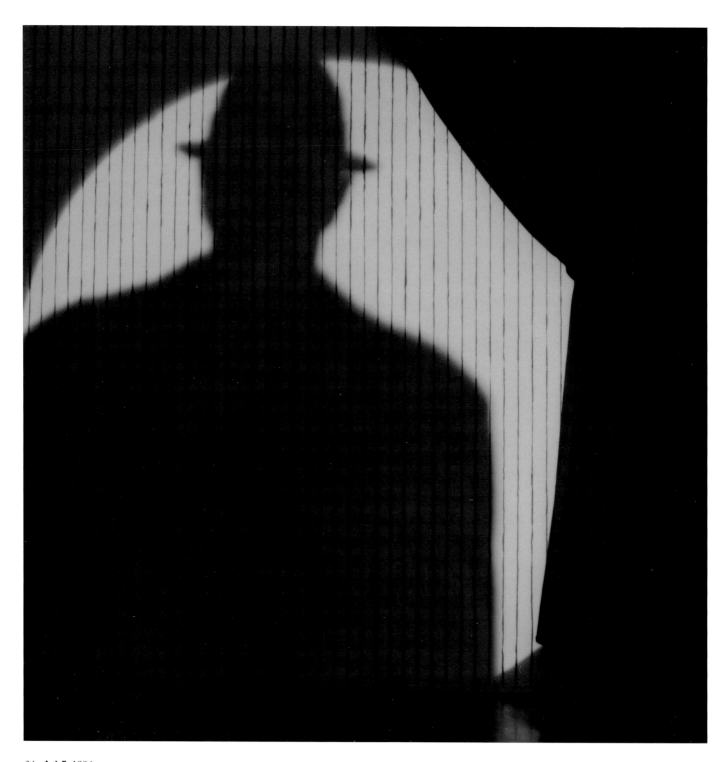

34. **Act 5**, 1994
Silver gelatin photograph with oil tint
49 x 49 inches
Courtesy the artist, Dunn & Brown Contemporary, Dallas;
P•P•O•W, New York; and Texas Gallery, Houston

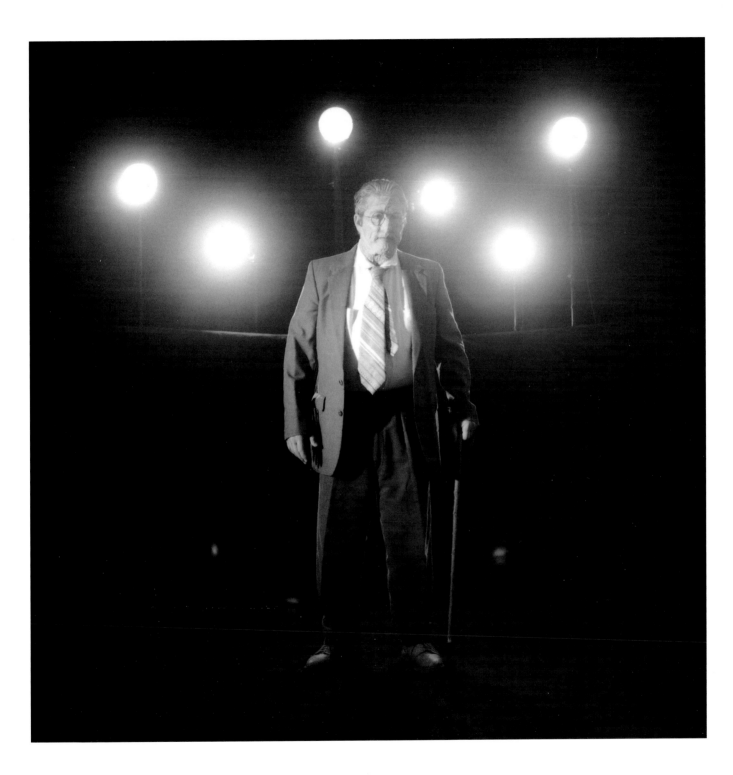

35. **Act 9**, 1994
Silver gelatin photograph with oil tint
49 x 49 inches
Courtesy the artist, Dunn & Brown Contemporary, Dallas;
P•P•O•W, New York; and Texas Gallery, Houston

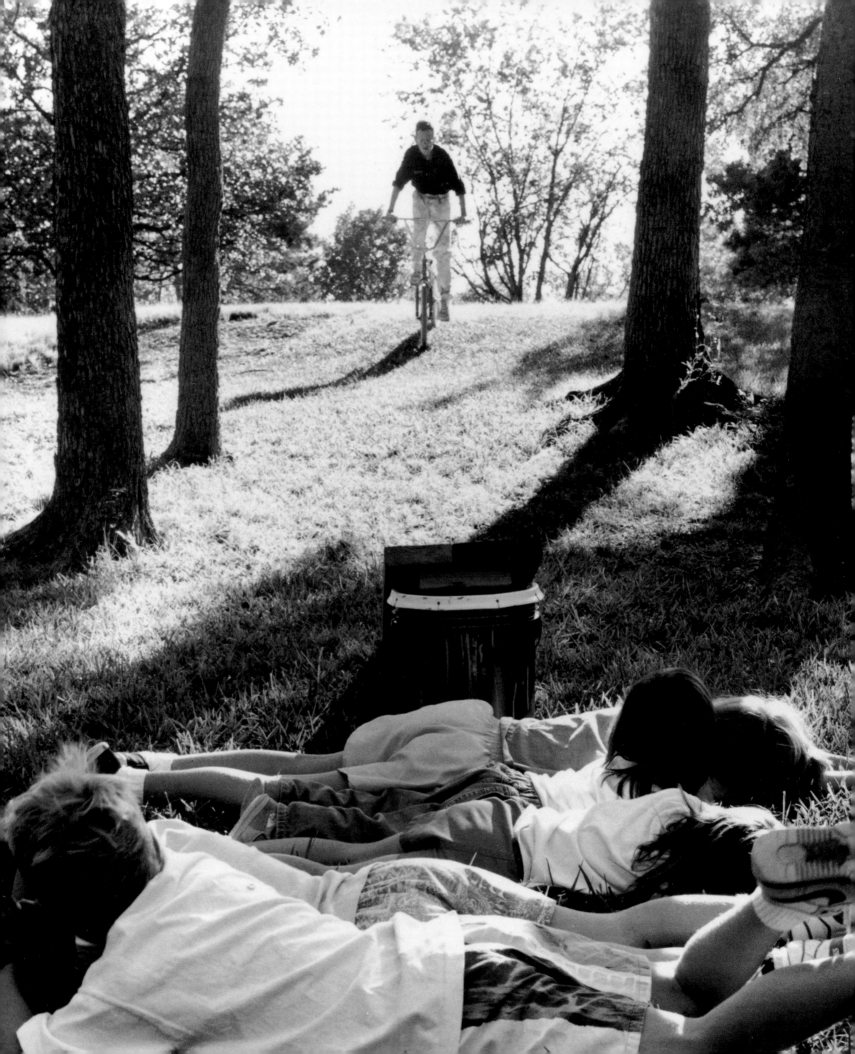

Nic Nicosia in Picture World

Dave Hickey

I would like to begin straightforwardly by suggesting that the most important attribute of Nic Nicosia's pictures, some of which are still and some of which move, is that they are *pictures* before they are anything else. Before they are photographs or cinema or images or objects or even art, Nicosia's works are pictures. More particularly, they are western pictures, with a Mediterranean provenance, rooted in the antique traditions of history painting, genre painting, and their theatrical equivalents. They tell imaginary stories by depicting scenes designed by the artist to fit within the rectangle (fig. 30). These scenes almost exclusively portray two or more human beings in a relationship arising out of their specific social circumstances. The frame, the human beings, the fugitive accouterments of their social reality, and the European tradition of picture-making are Nicosia's raw materials.

There is, in fact, hardly any practice or genre that tells stories in this way to which Nicosia's pictures do not allude in one instance or another, whose conventions are not appropriated, whose psychological atmospherics go unexploited. Even the most cursory glance through Nicosia's oeuvre reveals allusions to Poussinist history painting, Neapolitan *vanitas* painting, Claudian landscape, and genre painting of all orders. There are allusions to theater ranging from Viennese cabaret to grand opera. There are allusions to film ranging from German expressionism to the works of Antonioni and Fellini, from Hitchcock and Kubrick to the latest Hollywood confection. There are allusions to popular media, as well, ranging from comic books to product advertising to Rockwellian comic narrative. What we do *not* see, however, are many allusions to "modern photography," and we may infer from this, I think, that Nicosia's pictures do not aspire to the appearance of being "innocent" or "honest"—that they are never "spontaneous," nor *ever* nonfiction.

Neither the nonfiction world nor the nonfiction artist plays any role in Nicosia's narratives. The artist is present by virtue of his artistry, and the "real world" is re-designed into the frame. If we look at Nicosia's early work, in fact, we see him taking pains to distinguish his photographs from the aura of nostalgic "pastness," the cult of "spontaneous" formalism, and the covert assumption of documentary "truth" that infects nonfiction "art photography" to this day. As any number of critics have remarked, nonfiction photography is always about death—or, more specifically, about remoteness from the historical present. Nicosia, however, is urgently concerned with life as it is lived in the historical present; thus, one of the earliest pictures in this exhibition constitutes a kind of declaration of independence from the vestigial romantic mythologies of modernist photography.

At first glance, *Composition* (1980, pl. 3) has all classic tropes of "young modernist photographer art." It depicts the wall of an old garage hung with tools that show the signs of use. The

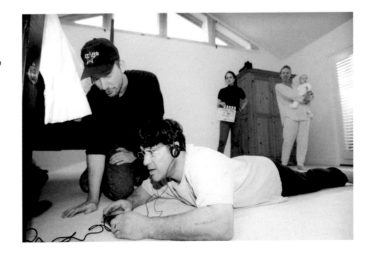

fig. 31 Nic Nicosia (in headphones) on the set of *Middletown Morning* with, left to right, Austin Lochheed, sound and lighting director; Noel Nicodemus, production assistant; Becky Wade, actress; and Bailey Cunningham, baby actress, 1999

fig. 30 Nic Nicosia, *Real Pictures #18* (detail), 1989, silver gelatin print, 48 x 60 inches. Private Collection

architecture of the garage provides the requisite armature for its "spontaneous" formalist composition; the tools themselves (since tools are used and these clearly have been) provide the inference of a displaced human narrative, while the weathered wall and the inelegant arrangement of old tools against it provide the requisite occasion for nostalgic contemplation of labor and loss. Nicosia, however, has subverted this cozy, cliché of a photographic occasion in a rather large way. He has covered the abject tools in pink paper and the weathered wall in brown paper with painted wood grain. He has dramatized the displaced narrative by inserting the speed lines of a car backing out of the garage, its headlights blazing on the open white door. Thus the "innocent nonfiction story" of a classic, modernist, photographic occasion is transformed by blatant authorial intervention into a scrap of cinematic narrative.

In this early work, however, I suspect that Nicosia has fictionalized the classic occasion less to tell a story than to make a point, to demonstrate the fictive nature of the occasion even *before* it was decorated—before it was pink and faux wood-grained with speedlines. In doing so, he seeks to disabuse us of the notion that there is such a thing as "nonfiction" photography, to rescue us from the whimsical fantasy that photographers find stories in the world (or "sermons in the stones," as Oscar Wilde accuses William Wordsworth of doing). Here, at the very beginning of his career, Nicosia insists that photographers tell constructed stories by excluding what doesn't interest them and arranging what does and that he will not pretend to be doing otherwise. The ground zero reality of photography for Nicosia, then, is neither external nor internal, neither documentary nor personal, but social and historical, so the true destiny of pictures, which are of necessity rooted in the moment of their making, is not to remind us that their occasions are remote and their subjects lost and dead (as "nonfiction" photographs cannot help but do), but to insist that the creatures portrayed were, in fact, alive and that they lived in the midst of real concerns that still concern us.

This is the ancient task of fiction and of fictional picture-making. It explains why a seventeenth-century painting of Neapolitan street life is more available to us than a nineteenth-century documentary photograph of the same subject. Beyond insisting on their social intimacy, however, there is very little one wishes to say about Nicosia's pictures by way of explanation and interpretation. One hesitates to intervene since the mystery and anxiety they occasion invariably derive from their disarming availability. Nicosia has extravagantly translated the timidly dysfunctional Arcadia of American suburbia (where so many of us live and so many more of us aspire to live) into the rich, interpretive rhetoric of western picture-making. He has done so with a cold eye and a warm heart, and, whether we like it or not, he has made that world vibrant and available to us forever. He has *nailed it*, arranged it, interpreted it, and redeemed it. As a conse-quence, explaining Nic Nicosia's works to a late twentieth-century American seems foolishly redundant, like explaining sand paintings to a Navajo. It is also a kind of theft, since a large measure of the enjoyment we experience before Nicosia's pictures resides in the vagrant pleasures of interpretation and recognition.

Nicosia makes his late twentieth-century suburban Arcadia available to us in the way that Andy Warhol, Roy Lichtenstein, Jim Rosenquist, and Tom Wesselman make mid twentieth-century urban America available to us—in the way that Eduard Manet, George Seurat and Auguste Renoir make the bourgeois life of nineteenth-century Paris available to us, and as John Everett Millais, Dante Rosetti and William Morris make nineteenth century England available to us. Like all these artists, Nicosia is a poet of bourgeois life, an "artist of modern times," at once critical of, and complicit in, its vagaries. He portrays "Domestic Dramas," "Near (modern) Disasters," "Real Pictures," vignettes of "Love + Lust"—and so devoted are these pictures to redeeming the manner and emotion of a single historical instant in a particular place that one hundred years from today, should we want some sense of that time and place, we will return with confidence to Nicosia's pictures to remind ourselves that such creatures lived the way they did.

Even today, from this short distance, Nicosia's portrayals of bourgeois, suburban life in the 1980s have about them the glow of exquisite historical icons—like the illustrative narratives in a medieval Book of Hours. Like moments set in amber, Nicosia's pictures capture the instant, once and forever, and this quality, in the domain of art, holds the promise of perpetuity. The question that interests me, however, and that *does* require some explanation and interpretation is why Nicosia's gift to us doesn't amaze and delight us *more*. Why aren't we more interested? The citizens of nineteenth century Paris and London and of mid twentieth-century New York were *interested* in the new kinds of lives they found themselves leading, and their lives were no more "new" or disconcerting than the lives we lead today. We live in amazing times, in amazing ways. Nicosia shows us this, and yet, we some-how seem more embarrassed than intrigued by the novelty and eccentricity of our existence—embarrassed on the one hand by its luxury and comfort, and on the other by the fact that an artist like Nicosia should make so much out of our making so little of it.

Keeping this in mind, let me suggest that, at the present historical moment, Nicosia is making a more radical art than he is generally credited with. There are, after all, times and places in the history of art when simply showing us things as they are with a modicum of heart is the most dangerous thing to do, and by giving us, not what we *want*, but what we flatter ourselves by thinking *other* people must want, Nicosia may very well be giving us what we need. This, I think, occasions the peculiar mixture of joy and discomfiture we feel as we stand before his pictures.

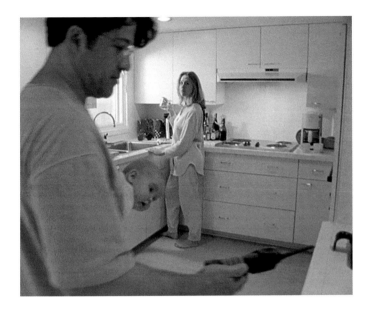

By sweetly forgiving us the comforts, foibles and desires for which we do not forgive ourselves, he calls our beliefs into question wherever they conflict with the circumstances of our lives. Thus, although Nicosia, even at his most astringent, never judges, people routinely judge his refusal to sit in judgment. Without questioning the veracity of Nicosia's narratives, they question the "appropriateness" and "relevance" of his decision to tell us these stories at this historical moment. In doing so, critics of Nicosia's "subject matter" tacitly acknowledge the dissonance of extreme ideological conviction and comfortable quotidian existence that has characterized cultural life in the late twentieth century.

Living as we do at the end of an age of belief, amidst the ragged tatters of "The Age of Ideology," we have, in recent years, dedicated ourselves to creating a nostalgic, disembodied art of conviction—a hedge against a future that has arrived and in the midst of which we have no choice but to live. Under these conditions, Nicosia's understanding portrayal of our ordinary lives constitutes a cold indictment of our intellectual denial, our verbal resistance, and our longing for older, internal certainties. Because, of course, we all still *believe* the right things. We believe in truth, justice, struggle, diversity, equality and the inevitable revolution. If you could look into our heads as we putter around the kitchen, cutting up fruit to blend into a healthy drink, you would see this very clearly. If you look at the art that populates our public spaces you see these convictions articulated in a hundred modes and media.

If you simply *look*, however, you see what Nic Nicosia sees: a middle-class human being in a heavily accessorized late twentieth-century kitchen, fearful of death and narcissistically preparing a potion that might perpetuate a pampered existence. It makes us uncomfortable to look at scenes like this (fig. 32). It doesn't

seem fair to dwell so heavily on the material accouterments of our lives, and it is certainly not fashionable, but it is not *wrong*, nor is it unimportant. It simply means that, at this point in the history of artistic discourse, Nicosia is doing wonderful work, but he is doing the "wrong" job. At a moment when we are all too comfortable with "documents" and "representations" that allow us to maintain the fiction of our disinterest and disengagement from the culture at large, Nicosia is making narrative *pictures* that engage us and insist on our understanding and complicity. This, I would suggest, is a surefire recipe for underappreciation, since the critical and public neglect of good art in its time rarely has anything to do with the work itself and everything to do with the job.

The quality of the work is rarely an issue. Good art always gives us *more*, although it may not give us more of what we want. Nor is style or medium an issue. At every point in the history of modern art, we find a proliferation of acceptable manners and media. The task that the artist has undertaken, however, and the nature of the *job* the work aspires to do, is critical to its contemporary appreciation—and always has been. Every age embraces a wide range of styles and media, but no age sanctions more than a limited number of acceptable jobs. In recent years, there have really been only two accredited artistic tasks, both of which are intrinsically utopian, obsessed with the purely internal and the purely external. We privilege documentary political critique as a mode of personal expression, and we privilege personal expression as a documentary form of political critique.

Both of these tasks address the plight of individuals (or individual identities) in their abject relation to prevailing cultural and governmental superstructures. In any context where this genre of work is dominant, Nic Nicosia's art, which addresses the plight of the individuals in groups of two or more, within the historical and social circumstances of a specific culture, is bound to seem oddly, almost inexplicably dissonant. The irony, of course, is that Nicosia has created a visual language to talk about the ordinary social world of this particular historical moment, that cannot be talked about in the ordinary artistic patois of the day. In a world where the personal is political, Nicosia shows us a world where the personal is social, and the political is irrevocably historical. In a landscape of cynical utopias, however, Nicosia's dysfunctional, guilt-ridden cosmopolitan Arcadia will continue to demand our attention and subversively reward it, simply because we recognize it and recognize ourselves within it, whether we wish to or not. This is what serious art does.

fig. 32 Nic Nicosia, still from *Middletown Morning*, 1999, 16mm film. Courtesy the artist, Dunn & Brown Contemporary, Dallas; P·P·O·W, New York; and Texas Gallery, Houston

Film and Video

1997–99

So...You Wanna Be an Artist

Like all other aspects of my work, actually of my life, I feel that I can do it all, and that I will learn what's necessary on my own. It's a flaw I think. With movies there is so much to learn, therefore I started as I had finished with the stills: minimally.

The guy in this film is just a man, a generic man who acts as an authority figure. He's a kind of subconscious figure, like a thought or dialogue bubble over your head. Is it a joke to be an artist? Is your work bad? Does this guy know anything about art? Does he even want to?

Middletown

For me making movies has become completely absorbing, it's all I want to do. They are difficult to pull off, there are weeks and weeks of planning, writing and re-writing of a script, testing, making mistakes, total involvement—I'm so into it. Want to know the influence for *Middletown?* See "Real Pictures" (the series).

We had put flyers on every door in my neighborhood stating the shooting schedule, the kind of car that would be carrying the camera, and asking people to please not wave to us, not to look in the camera's direction or inhibit its progress.

The neighbors and the other actors were totally cooperative. There were no dress rehearsals, I just discussed their placement in the streets, briefly directed the actors with their parts and timing, and then did a few test runs. It's one long uninterrupted shot and the shoot was complete after four takes in 100° weather. I thought it went beautifully but when we viewed the footage, we realized that the whole thing was screwed up with several severe "blinks" from the camera. I soon found out that the walkie-talkies we used and my digital video camera worked on the same frequency, and we had that frequency jacked-up to cover the distance of the neighborhood. Walkie-talkie *on*—blink; walkie-talkie *off*—blink . . .

Thanks to the kindness of my cast and crew, they agreed to a reshoot. It happened a month later—on another 100° day.

The music is so important here. It completes and adds to the surrealism and circus atmosphere.

Moving Picture

The other movies were on digital video, but I had originally learned to make motion pictures when TV news stories were still shot on film stock. I like film. Film provides a certain atmosphere, believability, and beauty.

This project was a challenge, mainly because in addition to directing, I shot it while wielding a twenty-something-pound camera attached to a makeshift Steadicam stabilizer made out of a cut-up tripod and bungy cords wrapped around my neck. At the same time I was sweating my ass off, trying to direct the actors, watch the viewfinder, and just hold the freaking camera in the right position.

I used a friend's house whose decorating and floor plan fit my needs. I wanted to take the camera from the outside setting of *Middletown* and go inside where a sequence of certain events would take place.

Middletown Morning

Within a period of one week I was told by various and unconnected people that I should consider acting. Why are they saying that? It's weird. Really, it kind of freaked me out. No way!—I want to write and direct. Then even more freakish, at the end of that week, on the Saturday night two days before the scheduled three-day shoot, Jimmy Sasso who I had cast to play "the artist/ husband/ dad" called to tell me he had been in a car accident and had staples in his head. *Middletown Morning* . . . introducing me, as an actor.

It's about an artist, a morning, and a newspaper review; all taking place somewhere in middle America. At one point, the artist's New York dealer tells him he's being arrogant and he responds, "This isn't arrogance. I'm living in Middletown, America, for crying out loud! This is insecurity!"

—*N.N.*

So...You Wanna Be an Artist

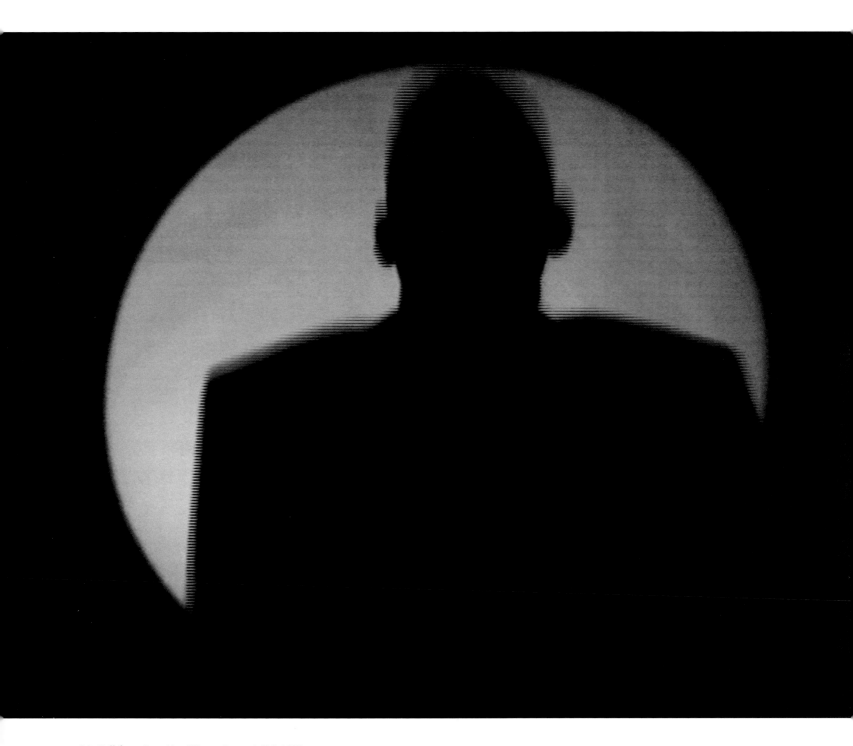

36. Still from **So...You Wanna Be an Artist**, 1997
Digital video
Courtesy the artist, Dunn & Brown Contemporary, Dallas;
P•P•O•W, New York; and Texas Gallery, Houston

Middletown

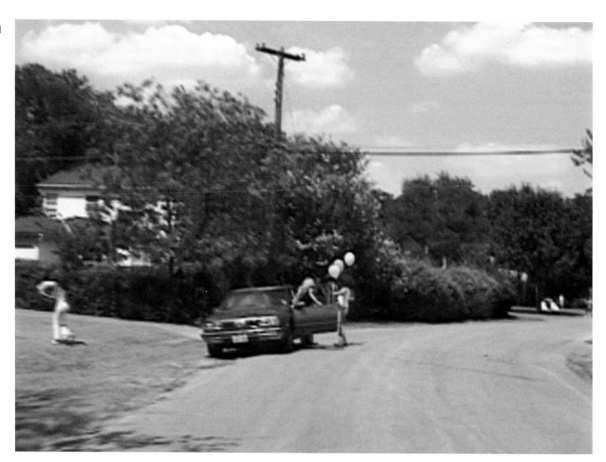

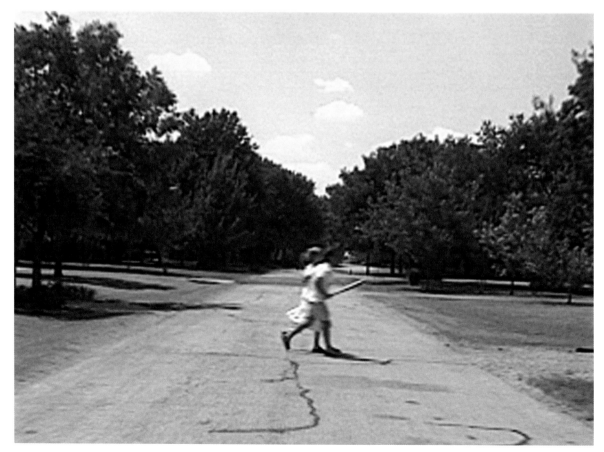

37–40. Stills from
Middletown, 1997
Digital video
Courtesy the artist, Dunn
& Brown Contemporary,
Dallas; P•P•O•W, New York;
and Texas Gallery, Houston

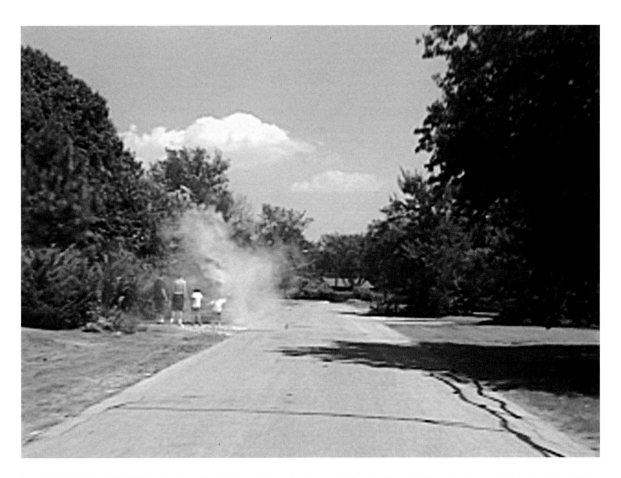

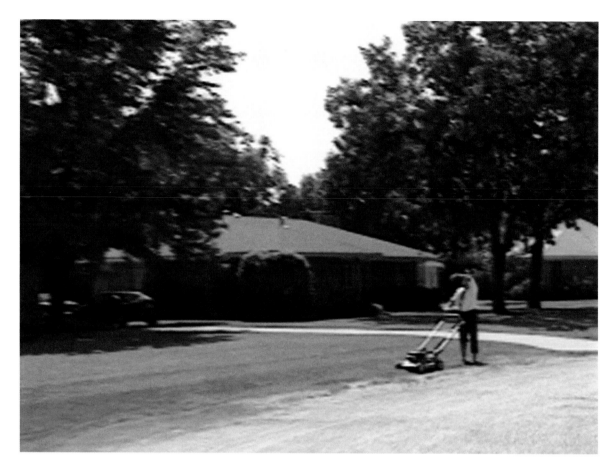

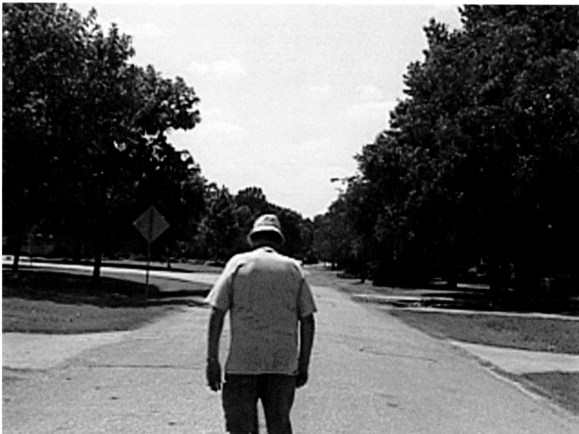

41–44. Stills from
Middletown, 1997
Digital video
Courtesy the artist, Dunn
& Brown Contemporary,
Dallas; P•P•O•W, New York;
and Texas Gallery, Houston

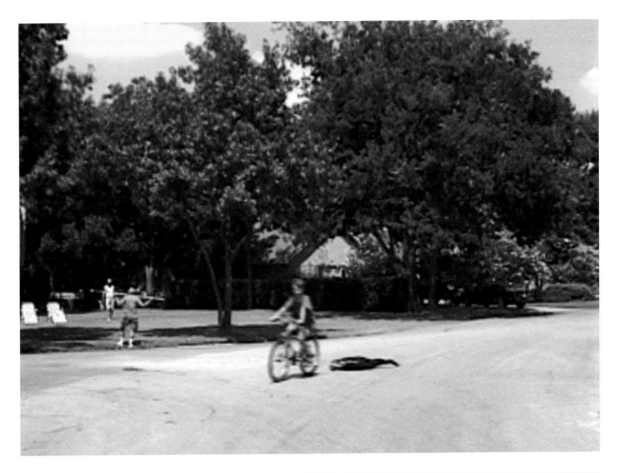

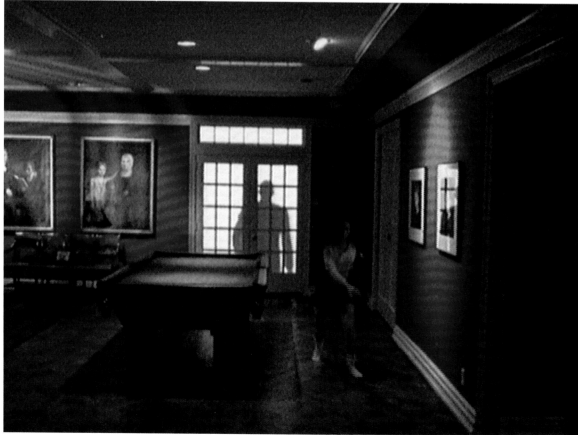

45–48. Stills from
Moving Picture, 1998
16mm film
Courtesy the artist, Dunn
& Brown Contemporary,
Dallas; P•P•O•W, New York;
and Texas Gallery, Houston

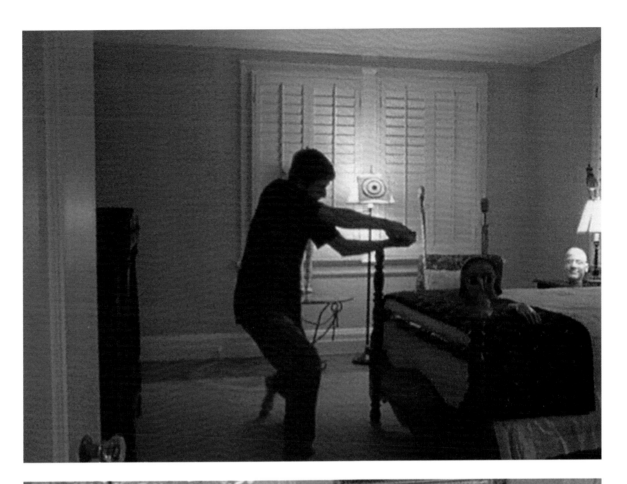

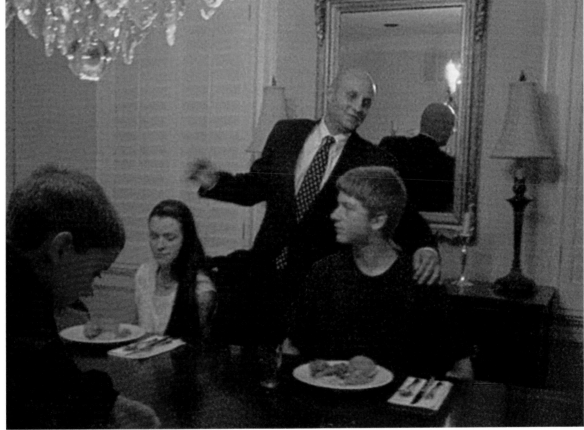

Middletown Morning

49–51. Stills from
Middletown Morning, 1999
16mm film
Courtesy the artist, Dunn & Brown Contemporary, Dallas;
P•P•O•W, New York; and Texas Gallery, Houston

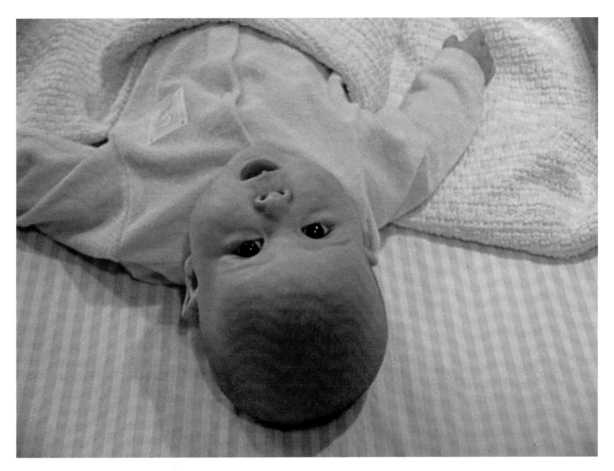

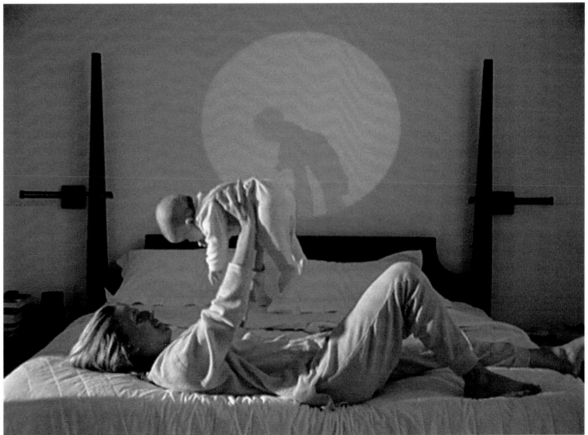

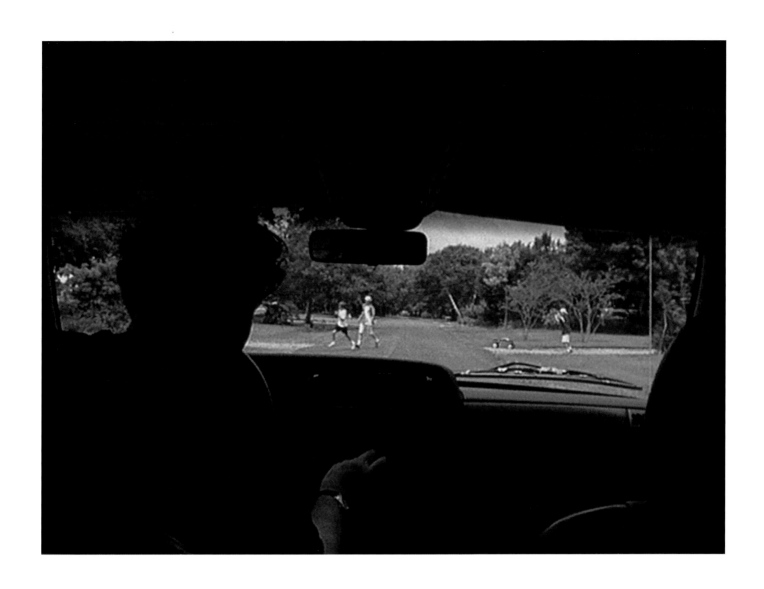

52–54. Stills from
Middletown Morning, 1999
16mm film
Courtesy the artist, Dunn & Brown Contemporary, Dallas;
P•P•O•W, New York; and Texas Gallery, Houston

Catalogue of the Exhibition

The term "chromogenic photograph" refers to color photographs made from negatives (example: a Type C print). The term "silver dye bleach photograph" refers to color photographs made from positive transparencies (example: a Cibachrome print).

Dimensions are given in inches, height preceding width. Cross references to reproductions appear in italics to the right of the title. Unless otherwise noted, all works are courtesy the artist, Dunn & Brown Contemporary, Dallas; P•P•O•W, New York; and Texas Gallery, Houston.

EARLY WORKS

Untitled, 1979 *fig. 22*
Chromogenic photograph
12 3/4 x 19

Cityscape #1, 1980 *fig. 5*
Chromogenic photograph
24 x 36

Composition, 1980 *pl. 3*
Chromogenic photograph
19 x 29

Mail Boxes, 1980 *page 1*
Chromogenic photograph
20 x 30

Pay-Per Phones, 1980 *pl. 2*
Chromogenic photograph
20 x 30
Private Collection, Houston

Coloring Book, page 2, 1981 *fig. 25*
Chromogenic photograph
30 x 40

Wall Paper, 1981 *pl. 1*
Chromogenic photograph
20 x 30

River, 1981
Chromogenic photograph
20 x 30
Collection Dallas Museum of Art,
General Acquisitions Fund

Vacant, 1980-81
Chromogenic photograph
20 x 30

DOMESTIC DRAMAS

Domestic Drama #1, 1982 *pl. 4*
Chromogenic photograph
30 x 40
Photography Collection, Harry Ransom
Humanities Research Center, The University
of Texas at Austin

Domestic Drama #2, 1982 *fig. 27*
Chromogenic photograph
30 x 40
Collection Dallas Museum of Art,
Gift of Steve Dennie and Debra Joy Allen

Domestic Drama #3, 1982 *pl. 5*
Chromogenic photograph
30 x 40

Domestic Drama #6, 1982 *pl. 6*
Silver dye bleach photograph
40 x 50

NEAR (MODERN) DISASTERS

Near (modern) Disaster #2, 1983 *pl. 9*
Silver dye bleach photograph
40 x 50
Collection Frito-Lay Inc., Plano, Texas

Near (modern) Disaster #4, 1983
Silver dye bleach photograph
40 x 50
Collection Solomon R. Guggenheim
Museum, New York: Exxon Corporation
Purchase Award

Near (modern) Disaster #7, 1983 *pl. 8*
Silver dye bleach photograph
40 x 50
Collection Frito-Lay Inc., Plano, Texas

Near (modern) Disaster #8, 1983 *pl. 7*
Silver dye bleach photograph
40 x 50
Collection Cece Smith and John Ford Lacy,
Dallas

THE CAST

Bill and Pete, 1985 *pl. 10*
Silver dye bleach photograph
50 x 40

Tristano, 1985 *pl. 11*
Silver dye bleach photograph
40 x 43

Ms. D'Avignon, 1985 *pl. 12*
Silver dye bleach photograph
40 x 47

LIFE AS WE KNOW IT

Like Photojournalism, 1986 *pl. 14*
Silver dye bleach photograph
48 x 48
Collection Dallas Museum of Art,
The Karl and Esther Hoblitzelle Collection,
Gift of the Hoblitzelle Foundation

Untitled (Sam), 1986 *pl. 13*
Silver dye bleach photograph
48 x 67
Collection Dallas Museum of Art,
The Karl and Esther Hoblitzelle Collection,
Gift of the Hoblitzelle Foundation

Vacation, 1986 *fig. 26*
Silver dye bleach photograph
48 x 48
Collection Dallas Museum of Art,
The Karl and Esther Hoblitzelle Collection,
Gift of the Hoblitzelle Foundation

Violence, 1986 *fig. 33, pl. 15*
Silver dye bleach photograph
48 x 58
Collection Dallas Museum of Art,
The Karl and Esther Hoblitzelle Collection,
Gift of the Hoblitzelle Foundation

Youth, 1986 *fig. 28*
Silver dye bleach photograph
48 x 72
Collection Dallas Museum of Art,
The Karl and Esther Hoblitzelle Collection,
Gift of the Hoblitzelle Foundation

REAL PICTURES

Real Pictures #2, 1987 *pl. 17*
Silver gelatin photograph
48 x 72
Collection Cece Smith and John Ford Lacy,
Dallas

fig. 33 *Violence* (detail), 1986, silver dye bleach photograph,
48 x 58 inches. Collection Dallas Museum of Art, The Karl and
Esther Hoblitzelle Collection, Gift of the Hoblitzelle Foundation.
(see pl. 15)

Real Pictures #4, 1987
Silver gelatin photograph
72 x 48
Collection Fredericka Hunter and Ian Glennie,
Houston

Real Pictures #6, 1987 *page 2*
Silver gelatin photograph
48 x 68
Collection Marguerite and Robert Hoffman,
Dallas

Real Pictures #8, 1988 *pl. 18*
Silver gelatin photograph
48 x 52
Collection Eileen and Peter Norton,
Santa Monica

Real Pictures #10, 1988 *pl. 19*
Silver gelatin photograph
36 x 84

Real Pictures #11, 1988 *page 3*
Silver gelatin photograph
79 x 48
Collection The Museum of Modern Art,
New York: E.T. Harmax Foundation Fund

Real Pictures #14, 1989 *fig. 23*
Silver gelatin photograph
48 x 48

Real Pictures #15, 1989 *pl. 16*
Silver gelatin photograph
48 x 50

Real Pictures #18, 1989 *fig. 30*
Silver gelatin photograph
48 x 60
Private Collection

Real Pictures #19, 1989 *pl. 20*
Silver gelatin photograph
48 x 48

LOVE + LUST

Love + Lust #1, 1990 *fig. 21*
Silver gelatin photograph with oil tint
30 x 30
Collection Mr. and Mrs. Sanford W. Criner,
Jr., Houston

Love + Lust #6, 1990 *pl. 25*
Silver gelatin photograph with oil tint
30 x 36

Love + Lust #8, 1990 *pl. 23*
Silver gelatin photograph with oil tint
30 x 43
Collection John and Susie Kalil, Houston

Love + Lust #11, 1990 *pl. 21*
Silver gelatin photograph with oil tint
30 x 37
Collection New Orleans Museum of Art:
Gift of Nic Nicosia, Linda Cathcart Gallery,
and Texas Gallery

Love + Lust #13, 1990 *pl. 22*
Silver gelatin photograph with oil tint
30 x 24

Love + Lust #14, 1990 *pl. 24*
Silver gelatin photograph with oil tint
30 x 30
Collection Mr. and Mrs. Stephen Susman,
Houston

UNTITLED

Untitled #2, 1991 *pl. 30*
Silver gelatin photograph with oil tint
36 x 36
Courtesy Gerald Peters Gallery, Dallas

Untitled #3, 1991 *pl. 27*
Silver gelatin photograph with oil tint
36 x 36
Collection Jeanne and Michael Klein, Houston

Untitled #4, 1992 *pl. 28*
Silver gelatin photograph with oil tint
36 x 36
Collection William Lincoln, Fort Worth

Untitled #5, 1991 *pl. 31*
Silver gelatin photograph with oil tint
36 x 36

Untitled #6, 1992 *pl. 26*
Silver gelatin photograph with oil tint
36 x 36
Collection Deborah Brochstein, Houston

Untitled #7, 1992 *back cover, pl. 32*
Silver gelatin photograph with oil tint
36 x 36
Collection of the Modern Art Museum of
Fort Worth, Museum Purchase, made possi-
ble by a grant from The Burnett Foundation

Untitled #8, 1992
Silver gelatin photograph with oil tint
36 x 36
Collection Eileen and Peter Norton,
Santa Monica

Untitled #9, 1992 *fig. 1*
Silver gelatin photograph with oil tint
36 x 36
Collection of the Modern Art Museum of
Fort Worth, Museum Purchase, made possi-
ble by a grant from The Burnett Foundation

Untitled #10, 1992 *pl. 29*
Silver gelatin photograph with oil tint
36 x 36
Collection of the Modern Art Museum of
Fort Worth, Museum Purchase, made possi-
ble by a grant from The Burnett Foundation

ACTS 1–9

Act 2, 1994 *fig. 29*
Silver gelatin photograph with oil tint
56 x 49
Collection Lisa and Charles Brown, Dallas

Act 4, 1994 *pl. 33*
Silver gelatin photograph with oil tint
49 x 62

Act 5, 1994 *pl. 34*
Silver gelatin photograph with oil tint
49 x 49

Act 7, 1994 *fig. 34*
Silver gelatin photograph with oil tint
49 x 60
Collection Debra Stevens, Dallas

Act 9, 1994 *pl. 35*
Silver gelatin photograph with oil tint
49 x 49

FILM AND VIDEO

So…You Wanna Be an Artist, 1997 *pl. 36*
Digital video
2 minutes

Middletown, 1997 *fig. 24, pl. 37–44*
Digital video
13:18 minutes

Moving Picture, 1998 *fig. 20, pl. 45–48*
16mm film
5:19 minutes

Middletown Morning, 1999 *cover, page 8,*
16mm film *fig. 32, pl. 49–54*
11:30 minutes

Film and Video Credits

So...You Wanna Be an Artist?
Written and directed by Nic Nicosia

Cast:
Shadow: Chris Corlae
Voice: Kim Corbet

Foley Sound: Nic Nicosia, Andy Deison
Audio/Video Post-production: Andrew Dean
Digital Post-production on Media 100®

Special thanks to Kaleta Doolin and Alan Govenar for use of the post-production facilities at the 5501 Columbia Art Center, Dallas.

© 1997 Real Pictures, All Rights Reserved

Moving Picture
Written and directed by Nic Nicosia

Cast in order of appearance:
Young boy: Alexander Newgard
Grandmother: Lisa Brown
Teen girl: Amy Nunley
Father: Chance Miller
Mother: Jennifer Stiles
Teen boy: David Harrel

Assistant Director: Melinda Obenchain
Camera: Nic Nicosia
Editing: Chris Corlae, Nic Nicosia
Music: Ernie Myers, Steve Powell
Lighting: Chris Corlae
Sound: Chris Corlae
Production Assistants: Winston Cutshall, Matt Domiteaux, Talley Dunn, Zoe Jones
Assistant to Nic Nicosia: Chris Corlae
Make-up and costume: Jennifer Jobe
Assistant Make-up: Katey Nicosia
Production coordinator: Johanna Graze
Colorist: Steve Franko
Film Processing and Transfer: Video Post and Transfer, Dallas
Digital Editing on Media 100® Systems

Sincere thanks to Ron and Harriet Scott and Robert and Marguerite Hoffman

© 1998 Real Pictures, All Rights Reserved

Middletown
Written and directed by Nic Nicosia

Cast in order of appearance:
Girl on the bench: Laura Cavern
Guy at van: Bobby Weaver
Van driver: Chris Corlae
Boy running #1: Alexander Newgard
Boy running #2: Zach Milsap
Girl at wagon: Abby Hoak
Boy on stilts: David Harrel
Boy on bike: Matt Domiteaux
Woman with dog: Nan Coulter
Dog: Barney Coulter
Teen at jeep #1: Michael Hammett
Teen at jeep #2: Johanna Graze
Man with lawn mower: Ralph Nicosia
Woman in robe: Becky Nicosia
Parent in middle of the street: Pat Nicosia
Girl in middle of the street: Leigh Nicosia
Girl in middle of the street: Kelly Nicosia
Girl with balloons: Lauren LaBarba
Girl with presents: Katy Priorie
Girl driving car: Katey Nicosia
Man with torch: Al Hirschler
Man with hose: Roy McKinney
Cowboy in suit #1: Bunky Vroom
Cowboy in suit #2: Joe Barber
Woman with Suburban: Lisa Hirschler
Woman in bathing suit: Debra Stevens
Man with bat: Blake Brown
Man crossing the street: Dr. Ralph Nicosia

Assistant Director: Andy Deison
Camera: Nic Nicosia
Music: Ernie Myers, Steve Powell
Production Assistants: Winston Cutshall, Reno Hechtman, Craig Reeves
Post Production: Nic Nicosia
Digital Editing on Media 100® Systems

Special thanks to my neighbors, the residents of Middleton Road and Ridge, Shirley, and Crowley Streets for their participation and cooperation.

© 1997 Real Pictures, All Rights Reserved

Middletown Morning
Written and directed by Nic Nicosia

Cast in order of appearance:
Paper boy #1: Jimmy Garmendia
Paper boy #2: Travis Guthrie
Paper boy #3: Alex Newgard
Woman: Rebecca Wade
Man: Nic Nicosia
Baby: Bailey Cunningham
Baby-sitter: Lisa Brown
Shadow Man and Doll Animation: Chris Corlae
Humming: Danielle Daboub

Assistant Director: Melinda Obenchain
Camera: Megan Flax, Nic Nicosia
Editing: Nic Nicosia
Music: Ernie Myers and Steve Powell
Lighting and Location Sound: Austin Lochheed
Sound Effects and Sound Editing: Nic Nicosia
Foley Sound: Nic Nicosia, Brooke Nicosia
Art Direction: Melinda Obenchain
Line Producer: Melinda Obenchain
Production Assistants: Noel Nicodemus, Zoe Jones
Preproduction Assistants: Chris Corlae, Matt Domiteaux, Katey Nicosia, Jimmy Sasso, Reese Wade
Italian Translations: Beth Taylor
Baby Wrangler: Cherie Cunningham (Bailey's mom)
Post Production Technical Advice: Andrew Dean, Jerry Keelin, Winston Cutshall, David Harrel
Colorist: Steve Franko
Film Processing and Transfer: Video Post and Transfer, Dallas
Digital Editing on Media 100® Systems
DVD Mastering: Magic Video, Dallas

Grateful acknowledgment to Debbie Stevens for letting us invade her home.

© 1999 Real Pictures, All Rights Reserved

Biography

Born 1951, in Dallas
1974, B. A. (Radio, TV, Film), University of
North Texas, Denton
Lives and works in Dallas

One-Person Exhibitions

1981
Nic Nicosia/Photographs, Brown Lupton
Gallery, Texas Christian University, Fort
Worth, October 12–30.

1982
Nic Nicosia, Artists Space, New York,
November 6–December 4.
Nic Nicosia/Domestic Dramas, Delahunty
Gallery, Dallas, December 18–February 2,
1983.

1983
Nic Nicosia, Light Song Gallery, University of
Arizona, Tucson, March 16–April 8.

1984
*Nic Nicosia, Photographs: "Domestic Dramas"
and "Near (modern) Disasters,"* Akron Art
Museum, Akron, Ohio, January 29–March
25. Brochure, text by Marcianne Herr.
Nic Nicosia/Near (modern) Disasters,
Delahunty Gallery, New York, January 31–
March 3.
Nic Nicosia: Recent Work, Jane Corkin
Gallery, Toronto, June 9–July 11.

1985
Nic Nicosia's Realities, Milwaukee Art Museum,
Milwaukee, May 24–September 22.
Brochure, text by Verna Curtis.
*Nic Nicosia: Domestic Dramas and Near
(modern) Disasters*, The Houston Center
for Photography, Houston, September
6–October 20.
The Cast, Pfeifer Gallery, New York, October
19–November 22.
New Photographs—Nic Nicosia, Dart Gallery,
Chicago, November 15–December 10.

1986
Concentrations 13: Nic Nicosia, Dallas Museum
of Art, Dallas, February 1–March 31.
Brochure, text by Sue Graze.
Nic Nicosia: Recent Photographs, Wellesley
College Museum, Wellesley, Massachusetts,
February 8–March 23.

The Cast, Texas Gallery, Houston, March 1–29.
Nic Nicosia, Film in the Cities, St. Paul,
Minnesota, May 7–28.
Nic Nicosia, Maurice Keitelman Gallery,
Brussels, May 22–July 15.
Nic Nicosia: Photographs, Eve Mannes Gallery,
Atlanta, September 12–October 13.

1987
Nic Nicosia, Life as We Know It, Albert Totah
Gallery, New York, February 28–March 26.
Nic Nicosia: Life as We Know It, Barry
Whistler Gallery, Dallas, June 5–July 8.
Nic Nicosia, Life as We Know It, Janie Beggs
Fine Art, Ltd., Aspen, Colorado, June
13–July 2.
Nic Nicosia, Photographs, Arthur Roger Gallery,
New Orleans, September 26–October 14.
Nic Nicosia, Life as We Know It, University Art
Galleries, Wright State University, Dayton,
Ohio, November 9–December 6.
*Nic Nicosia, Real Pictures and Life as We
Know It*, Art Museum of Southeast Texas,
Beaumont, December 8–January 3, 1988.

1988
Nic Nicosia: Real Pictures, Texas Gallery,
Houston, April 16–May 10.
Nic Nicosia: Real Pictures, Bruno Facchetti Gal-
lery, New York, October 29–November 29.
Catalogue, text by Susan Freudenheim.

1989
Nic Nicosia: Real Pictures, Dart Gallery,
Chicago, March 24–April 29.
Nic Nicosia: Real Pictures, Barry Whistler
Gallery, Dallas, September 16–30.

1990
Nic Nicosia, New Photographs: Real Pictures,
Linda Cathcart Gallery, Santa Monica,
California, opened January 13.
Nic Nicosia: Recent Photographs, Bruno
Facchetti Gallery, New York, April 5–28.

1991
A Progression of Photographs, University of
North Texas Art Gallery, Denton, March
21–April 13.
Nic Nicosia: Love + Lust, Dart Gallery,
Chicago, April 5–27.
Nic Nicosia, Love + Lust: New Photographs,
Linda Cathcart Gallery, Santa Monica,
California, July 20–August 17.

Nic Nicosia, Love + Lust, Barry Whistler
Gallery, Dallas, November 1–30.

1992
Nic Nicosia: Love + Lust, Texas Gallery,
Houston, January 23–February 22.
Nic Nicosia: Real Pictures, San Angelo Museum
of Fine Arts, San Angelo, Texas, February
27–March 29.
Nic Nicosia: Love + Lust, Richard Foncke
Gallery, Ghent, Belgium, November 13–
December 6.

1993
Nic Nicosia: Love + Lust, Raab Gallery, London,
March 2–April 17. Brochure, text by Luc
Lambrecht.
Nic Nicosia: New Work, Texas Gallery, Houston,
September 11–October 9.
Nic Nicosia, Linda Cathcart Gallery, Santa
Monica, California, October 2–November
6.
Nic Nicosia: Untitled, Gerald Peters Gallery,
Dallas, December 10–January 15, 1994.

1994
Nic Nicosia, Richard Foncke Gallery, Ghent,
Belgium, March 25–May 1.
Nic Nicosia, P•P•O•W, New York, June 2–
July 15.

1996
Nic Nicosia: Act Series, 1994–95, Richard
Foncke Gallery, Ghent, Belgium, March 16–
April 21.

1997
Nic Nicosia: Acts and Sex Acts, Zolla/Lieberman
Gallery, Chicago, February 7–March 15.
Nic Nicosia, Life, 5501 Columbia Art Center,
Dallas, February 21–June 7.
Acts and Sex Acts, P•P•O•W, New York, March
20–April 19.
Nic Nicosia: Acts, Sex Acts, and Video,
Gerald Peters Gallery, Dallas, October 16–
November 15.

1998
Nic Nicosia: Middletown, Stephen Wirtz
Gallery, San Francisco, September 1–26.

Group Exhibitions

1980

Voetman Show, North Texas State University, Denton, Spring.

Texas Only, Laguna Gloria Art Museum, Austin, Texas, August 23–September 14.

1981

Texas Photo Sampler, Washington Project for the Arts, Washington, D.C., January 6–31. Traveled to Camerawork Gallery, San Francisco, October 13–November 14. Catalogue, text by Ed Hill and Al Nodal.

The New Photography, Contemporary Arts Museum, Houston, January 17–February 22. Catalogue, text by Linda L. Cathcart and Marti Mayo.

Collection 81: The Road Show, 2 Houston Center, Houston, March 5–April 3. Catalogue, text by Ron Gleason.

Invitational 81, Longview Museum and Arts Center, Longview, Texas, March 7–April 24.

Photoworks: Steve Dennie/Nic Nicosia, 500 Exposition Gallery, Dallas, April 11–May 9.

Staged Shots, Delahunty Gallery, Dallas, April 11–May 6.

Space Framed I, Harvard University Graduate School of Design, Cambridge, Massachusetts, September–October.

American Vision, 80 Washington Square East Galleries, New York University, New York, October 13–November 6.

Nic Nicosia and Stephen Dennie, Galveston Arts Center, Galveston, Texas, November 6–29.

1982

Photography, Hallwalls Contemporary Arts Center, and Center for Exploratory and Perceptual Art (CEPA Gallery), Buffalo, New York, February 5–27.

Henrich, Nicosia, Williams, Texas Gallery, Houston, May 28–June 30.

Beyond Photography: The Fabricated Image, Delahunty Gallery, New York, June 8–July 31.

Fabricated Images/Color Photography, Magnuson-Lee Gallery, Boston, September 11–October 20.

1983

Images Fabriquées, Musée national d'art moderne, Centre Georges Pompidou, Paris, February 10–March 13. Traveled. Catalogue, text by Alain Sayag.

Touch With Your Eyes, Feel With Your Mind: Surfaces in Contemporary Art, Laguna Gloria Art Museum, Austin, Texas, February 19–March 27.

Group Exhibition, Delahunty Gallery, New York, March 15–April 6.

Whitney Biennial, Whitney Museum of American Art, New York, March 15–May 29. Catalogue, text by John Hanhardt, Barbara Haskell, Richard Marshall, and Patterson Sims.

The New Orleans Triennial, New Orleans Museum of Art, New Orleans, April 8–May 22. Catalogue, text by Linda L. Cathcart and William S. Fagaly.

Three-Dimensional Photographs, Castelli Graphics, New York, April 12–May 4.

Showdown (Part V), Foto Gallery, New York, May 21–June 11. Catalogue.

Southern Fictions, Contemporary Arts Museum, Houston, August 2–September 4. Catalogue, text by William S. Fagaly and Monroe K. Spears.

Making Photographs: 6 Alternatives, North Texas State University, Denton, Texas, August 29–September 16. Traveled to Midwestern University, Wichita Falls, Texas, November 18–January 27, 1984.

New Perspectives in American Art: 1983 Exxon National Exhibition, Solomon R. Guggenheim Museum, New York, September 30–November 27. Catalogue, text by Diane Waldman.

1984

New Works, Delahunty Gallery, Dallas.

Anxious Interiors, Laguna Beach Museum of Art, Laguna Beach, California, January 6–February 19. Traveled under the auspices of The Art Museum Association of America, San Francisco, 1984–85. Catalogue, text by Elaine K. Dines.

Construction/Photographs, San Antonio Art Institute, San Antonio, January 19–February 24.

Painting/Photography, Thorpe Intermedia Gallery, Sparkhill, New York, January 19–February 24.

New Images in Photography, Visual Arts Museum, New York, March 5–24.

Visions of Childhood: A Contemporary Iconography, Whitney Museum of American Art, Downtown Branch, New York, March 28–May 11. Catalogue.

Modern Masters, 8 Interview Photographers, Delahunty Gallery, Dallas, April 14–May 23.

Boats and Planes: Notions of Movement, The Art Center, Waco, Texas, April 28–June 10.

Painting and Sculpture Today 1984, Indianapolis Museum of Art, Indianapolis, May 1–June 10. Catalogue, text by Helen Ferulli.

A Decade of New Art, Artists Space, New York, May 31–June 30. Catalogue, text by Linda L. Cathcart.

Large Scale Photography, Dart Gallery, Chicago, September 14–October 9.

Summer Salon, Jane Corkin Gallery, Toronto, December.

1985

The Crescent Collection II: A Celebration of Texas Artists, Crescent Marketing Center, Dallas, January 31–May 15.

Texas Currents: Part I, San Antonio Art Institute, San Antonio, September 26–October 31. Catalogue.

Comic Relief, Barry Whistler Gallery, Dallas, December 7–January 8, 1986.

1986

Texas Group Show, Texas Gallery, Houston, January 7–February 1.

Texas Time Machine, Cullen Center, Houston, January 16–May 15. Traveled to Sheraton Gallery, Sheraton Dallas Hotel and Towers, Dallas, July–August. Catalogue, text by Joan Robinson.

A Sense of Place: Contemporary Southern Art, Minneapolis College of Art and Design Gallery, Minneapolis, January 31–March 14. Catalogue, text by Eleanor Heartney.

Intersection: Artists View the City, Laguna Gloria Art Museum, Austin, Texas, February 8–April 6.

Before the Camera: A Selection of Contemporary Studio Tableaux, Burden Gallery, Aperture Foundation, New York, February 11–March 29.

Intimate/Intimate, Turman Gallery, Indiana State University, Terre Haute, March 22–April 22. Catalogue, text by Bert Brouwer and Charles S. Mayer.

Photographic Fictions, Whitney Museum of American Art, Fairfield County, Stanford, Connecticut, April 4–May 28. Catalogue.

La magie de l'image, Musée d'art contemporain de Montréal, Montreal, June 1–August 31. Catalogue, text by Paullette Gagnon.

America, Albert Totah Gallery, New York, June 14–July 12.

Photography: Suggestions and Facts. Ann Chamberlain, Donigan Cumming, Nic Nicosia, Mandeville Gallery, University of California, San Diego, La Jolla, October 10–November 2.

1987

Group Show, James Corcoran Gallery, Los Angeles, January 8–February 7.

Arrangements for the Camera: A View of Contemporary Photography, The Baltimore Museum of Art, Baltimore, February 10–April 19.

Derek Boshier, Nic Nicosia, Susan Whyne, Albert Totah Gallery, New York, April 29–May 13.

Crime and Punishment, Schreiber/Cutler Inc., New York, May 2–30.

Torino Fotografia 87, Turin, Italy, June. Catalogue, text by Daniela Palazzoli, et al.

True Wit, Cullen Center, Houston, July 30–October 8.

Emerging Artists, 1978–1986: Selections from the Exxon Series, Solomon R. Guggenheim Museum, New York, September 3–November 1. Catalogue, text by Diane Waldman.

Third Coast Review: A Look at Art in Texas, Aspen Art Museum, Aspen, Colorado, September 10–October 25. Catalogue, text by Annette DiMeo Carlozzi.

Contemporary Photographic Portraiture, Espace lyonnais d'art contemporain (E.L.A.C.), Lyons, France, October 7–November 22. Catalogue, text by Bernard Brunon.

Photographs by Charles Hovland and Nic Nicosia, Honolulu Academy of Arts, Honolulu, November 5–December 13.

Small Wonders, Barry Whistler Gallery, Dallas, November 13–December 5.

1988

Photographic Truth, Bruce Museum, Greenwich, Connecticut, January 31–March 27. Catalogue, text by Nancy Hall-Duncan.

Perceptual Subversion, Bruno Facchetti Gallery, New York, February 6–March 2.

Texas Narration: Derek Boshier and Nic Nicosia, Connecticut College, New London, February 22–March 8.

Evocative Presence: Twentieth-Century Photographs in the Permanent Collection of the Museum of Fine Arts, Houston, Museum of Fine Arts, Houston, February 27–May 1.

Fabrications, Sert Gallery, Harvard University, Cambridge, Massachusetts, March 3–April 10.

Photography on the Edge, Haggerty Museum of Art, Marquette University, Milwaukee, March 24–June 8. Catalogue, text by Noel Carroll and Curtis L. Carter.

Texas. Contemporary Art from Texas, Groninger Museum, Groninger, The Netherlands, March 31–May 15. Catalogue, text by Alison de Lima Greene and Frans Haks.

Group Exhibition, Dart Gallery, Chicago, April 30–June 4.

Vision/Television, JIPAM, Montpellier, France, May 16–June 4.

Lance Carlson, Nic Nicosia, Kenneth Shorr, Fahey/Klein Gallery, Los Angeles, July 16–August 27.

Life Stories: Myth, Fiction, and History in Contemporary Art, Henry Art Gallery, Seattle, September 16–November 6. Brochure, text by Chris Bruce.

1989

Staged Documents: Photographs by Tina Barney and Nic Nicosia, San Francisco Camerawork, San Francisco, March 16–April 22.

Painted Stories and Other Narrative Art, Laguna Gloria Art Museum, Austin, Texas, June 10–July 23.

Works on Paper, Barry Whistler Gallery, Dallas, July 15–September 9.

Nature and Culture: Conflict and Reconciliation in Recent Photography, The Friends of Photography/Ansel Adams Center, San Francisco, September 14–November 26.

Das konstruierte Bild. Fotografie—arrangiert und inszeniert, Kunstverein München, Munich, Germany, October 28–December 3. Traveled to Kunsthalle Nürnberg, Nuremberg, Germany, February 23–March 25, 1990; Forum Böttcherstrasse, Bremen, Germany, April 25–June 13, 1990; Badischer Kunstverein, Karlsruhe, Germany, July–August 1990. Catalogue, text by Michel Köhler and Andreas Vohwinckel.

1990

Reinventing Reality: Five Texas Photographers, Sarah Campbell Blaffer Gallery, University of Houston, Houston, February 17–April 1. Catalogue, text by Elizabeth Ward.

Family Stories, Newhouse Center for Contemporary Art, Snug Harbor Cultural Center, Staten Island, New York, April 28–September 2. Catalogue, text by Olivia Georgia.

Black and White: Works on Paper, Linda Cathcart Gallery, Santa Monica, California, July.

Art That Happens To Be Photography, Texas Gallery, Houston, December 11–January 26, 1991.

1991

Selections from the Permanent Collection, Laguna Gloria Art Museum, Austin, Texas, June 8–July 28.

Nic Nicosia and Bettina Rheims, Pace/MacGill Gallery, New York, July 11–August 31.

Pleasures and Terrors of Domestic Comfort, The Museum of Modern Art, New York, September 26–December 31. Catalogue, text by Peter Galassi.

Past/Present: Photography from the Permanent Collection of the Museum of Fine Arts, Houston, Museum of Fine Arts, Houston, December 8–January 19, 1992.

1992

Kunst Nu, Vereniging voor het museum van hedendaagse kunst te Gent, Museum van Hedendaagse Kunst Gent, Ghent, Belgium, January 21–February 20.

New Orleans Triennial: New Southern Photography, New Orleans Museum of Art, New Orleans, May 9–June 27. Catalogue, text by Nancy Barret and John Szarkowski.

No Man's Land, Richard Foncke Gallery, Ghent, Belgium, June 4–September 6.

Documenta IX, Museum Fridericianum, Kassel, Germany, June 13–September 20. Catalogue, text by Bart De Baere, Carnelius Castoriadis, Claudia Herstatt, Jan Hoet, Heiner Müller, et al.

1993

Autoportraits contemporains: Here's Looking at Me, Espace lyonnais d'art contemporain (E.L.A.C.), Centre d'echanges de Perrache, Lyons, France, January 29–April 30. Catalogue, text by Bernard Brunon.

Love and Other (Fatal) Attractions, Santa
 Barbara Contemporary Arts Forum, Cali-
 fornia, Santa Barbara, February 6–March 27.

*Vivid: Intense Images by American Photog-
 raphers*, Raab Galerie, Berlin, May 19– July
 31. Traveled to Raab Boukamel Galleries,
 London, August 11–September 31; Gian
 Ferrari Arte Contemporanea, Milan, Italy,
 October 11–November 31. Catalogue, text
 by Victoria Espy Burns, Kathryn Hixson,
 Judith Russi Kirshner, and Jerry Saltz.

Texas/Between Two Worlds, Contemporary
 Arts Museum, Houston, November 19–
 February 6, 1994. Traveled to Modern Art
 Museum of Fort Worth, Fort Worth, April
 24–June 19, 1994; Art Museum of South
 Texas, Corpus Christi, September 16–
 November 23, 1994. Catalogue, text by
 Peter Doroshenko.

1994

Zomer '94, Richard Foncke Gallery, Ghent,
 Belgium, August 8–September 11.

*Family Lives: Photographs by Tina Barney,
 Nic Nicosia, and Catherine Wagner*,
 Corcoran Gallery of Art, Washington,
 D.C., December 10–February 13, 1995.
 Brochure, text by Terrie Sultan.

1995

Visions of Hope and Despair, Museum of
 Contemporary Art, Chicago, March 25–
 May 30. Brochure, text by Nadine
 Wasserman.

Fotografie als Bild, Kunstverein Braunschweig,
 Braunschweig, Germany, April 28–June 18.

Link, Gerald Peters Gallery, Dallas, June 1–
 July 13.

Photographs from the Permanent Collection,
 Modern Art Museum of Fort Worth, Fort
 Worth, November 3–January 5, 1996.

1996

Telling Stories, Jacksonville Museum of
 Contemporary Art, Jacksonville, Florida,
 March 14–April 28. Catalogue, text by Paul
 Karabinis.

Link, Gerald Peters Gallery, Dallas, June 1–
 July 13.

Establishment Exposed, Dallas Visual Art
 Center, Dallas, November 1–December 13.
 Brochure, text by Marilyn Zeitlin.

1997

Link, Gerald Peters Gallery, Dallas, May 29–
 July 31.

*Re/View: The Collection of Photography at the
 Dallas Museum of Art*, Dallas Museum of
 Art, Dallas, March 4–May 11.

1998

Texas Wired, The Contemporary Art Center
 of Fort Worth, Fort Worth, January 17–
 February 22.

Projected Allegories, Contemporary Arts
 Museum, Houston, June 26–September 13.
 Catalogue, text by Dana Friis-Hansen,
 Lynn M. Herbert, and Alexandra Irvine.

Link, Gerald Peters Gallery, Dallas, July
 17–August 29.

7th New York Video Festival, Walter Reade
 Theater, Lincoln Center, New York, July
 17–23.

20 x 500: View from a Dallas Warehouse, 500X
 Gallery, Dallas, September 12–October 11;
 Richland College, Dallas, October 14–
 November 6; The Art Center of Waco, Waco,
 Texas, November 12–January 10, 1999.

Union/Reunion, Nexus Contemporary Art
 Center, Atlanta, September 12–October 17.
 Brochure, text by Teresa Bramlette.

1999

Wired for Living, The McKinney Avenue
 Contemporary, Dallas, February 27–April 3.

*Expansive Vision: Recent Gifts and Acquisi-
 tions of Photographs in the Dallas Museum
 of Art*, Dallas Museum of Art, Dallas,
 June 24–August 29.

Bibliography

1981

Kalil, Susie. "Photographic Crosscurrents." *Artweek*, February 7, 1981, pp. 1, 16.

Marvel, Bill. "League Lobbies Quality Show." *The Dallas Times Herald*, March 2, 1981, p. C1.

Mitchell, Charles Dee. "Pretty Pictures Give Way to Fabricated Reality." *Dallas Observer*, April 2, 1981, p. 13.

Murray, Joan. "New Photographics—An Esthetic Barometer." *Artweek*, April 18, 1981, pp. 1, 11.

Kutner, Janet. "Photographers call the shots with fantasy." *The Dallas Morning News*, May 2, 1981, pp. C1, C11.

Raczka, Robert. "Stephen Dennie/Nic Nicosia." *Artspace*, Fall 1981, pp. 62–63.

1982

Bannon, Anthony. "Big, New, Colorful Photographs." *The Buffalo News*, February 7, 1982, p. G1.

Bannon, Anthony. "Nobel Images Used to Transform Magazine Photographs Into Art." *Buffalo Evening News*, February 16, 1982, p. G1.

Huntington, Richard. "Neutrality of Camera Evidenced in Two Current Exhibits." *Buffalo Courier-Express*, February 21, 1982, p. F3.

Kalil, Susie. "Rooted in Ambiguity." *Artweek*, June 19, 1982, p. 14.

Grundberg, Andy. "Exploring the Impossible." *The New York Times*, July 11, 1982, p. H25.

Grundberg, Andy. "In Today's Photography, Imitation Isn't Always Flattery." *The New York Times*, November 14, 1982, pp. H31, H39.

Mitchell, Charles Dee. "Nicosia's Domestic Dramas." *Dallas Observer*, December 16–19, 1982, p. 15.

1983

Kutner, Janet. "Is It Live or Is It Nicosia?" *The Dallas Morning News*, January 17, 1983, pp. C1, C2.

Grundberg, Andy. "Photography: Biennial Show." *The New York Times*, April 1, 1983, p. C23.

"Camera at Work: Scene Stealers." *Life Magazine*, May 1983, pp. 10–11, 14, 16.

Freudenheim, Susan. "Nic Nicosia at Delahunty." *Art in America*, Summer 1983, p. 163.

Grundberg, Andy, and Carol Squiers. "Family Fables." *Modern Photography*, June 1983, pp. 78–83.

Freudenheim, Susan. "Nic Nicosia: One-Shot Realities." *Texas Homes*, July 1983, pp. 25–28.

Kutner, Janet. "In the Southern tradition." *The Dallas Morning News*, August 26, 1983, pp. 1C, 3C.

Russell, John. "Younger Americans; Visitors from the Past." *The New York Times*, September 30, 1983, p. C20.

Vetrocq, Marcia E. "1983 Triennial at the New Orleans Museum of Art." *Art in America*, October 1983, pp. 191, 193.

Larson, Kay. "The Baron's Bounties." *New York Magazine*, October 17, 1983, pp. 88, 90.

Preston, Malcolm. "The Promise of 11 Americans." *Newsday*, October 30, 1983, n.p.

Marcus, Jon. "The Guggenheim Dares the Future." *Cape Cod Times*, November 24, 1983, p. 21.

Manroe, Candace Ord. "The Art of Photography." *Dallas–Fort Worth Home and Garden*, December 1983, pp. 136–37.

1984

Princenthal, Nancy. "Guarding a Legacy, Securing the Future." *ARTnews*, January 1984, p. 155.

Mott, Michael. "Blurring the Border Between Sculpture and Photography." *The Sunday Express–News*, San Antonio, January 1984, p. G5.

Muchnic, Suzanne. "High Anxiety at the Laguna Beach Museum." *Los Angeles Times*, January 12, 1984, part VI, pp. 1, 6.

Brumfield, John. "An Accumulation of Narrative." *Artweek*, January 28, 1984, pp. 1–3.

Hayes, Robert. "Modern Masters." *Interview*, April 1984, p. 76.

Heartney, Eleanor. "Nic Nicosia." *Arts Magazine*, April 1984, p. 15.

Mays, John Bentley. "Nicosia's Visual One-Liners." *Toronto Globe*, June 14, 1984.

Hume, Christopher. "Across the Border into Filmland." *Toronto Star*, June 23, 1984.

Freeman, Phyllis, et al., ed., *New Art* (New York: Harry N. Abrams, Incorporated, 1984), p. 141.

Goldberg, Vicky. "Shocking Women Beautiful Men." *American Photographer*, December 1984, pp. 22–23.

1985

Kutner, Janet. ". . . Crescent Collection II." *The Dallas Morning News*, April 6, 1985, p. F1.

Freudenheim, Susan. "Art Texas Style." *Texas Homes*, May 1985, p. 45.

Davis, Douglas. "Seeing Isn't Believing." *Newsweek*, June 3, 1985, pp. 68–70.

"The Edge of Illusion." *Aperture*, Fall 1985, pp. 26–27.

Everingham, Carol J. "Critic's choice: In the Nic of time." *The Houston Post*, September 6, 1985, p. E3.

McCombie, Mel. "Vibrant Variety." *Austin American-Statesman*, October 10, 1985, p. D1.

Rapier, April. "Nic Nicosia: One-Frame Movies." *Spot*, Winter 1985, p. 16.

Lewis, Frank. "Fabricated to be Photographed." *Afterimage*, December 1985, pp. 18–19.

Kutner, Janet. "Works of art that make you laugh—and think." *The Dallas Morning News*, December 15, 1985, pp. C1, C15.

Freudenheim, Susan. "Pepsi melds business and art interests." *The Dallas Times Herald*, December 24, 1985.

1986

Higa, Yoshi. "Nic Nicosia, The Cast." *Nippon Camera*, January 1986, p. 134.

Kutner, Janet. "Photo Unreality." *The Dallas Morning News*, February 2, 1986, pp. C1, C9.

Mitchell, Charles Dee. "The Cast Features a Little Help from Nic's Friends." *Dallas Observer*, February 27, 1986, p. 3.

Day, Meredith Fife. "Nicosia at Wellesley." *Century Newspapers*, March.

Thornton, Gene. "When Tableaux Vivants Flowered in the Magazines." *The New York Times*, March 2, 1986, p. H29.

Symkus, Ed. "Unnatural Disasters." *TAB*, March 11, 1986, sec. 3, p. 12.

Pulda, Ellen. "Freeze Frames . . Nicosia" *New West*, March 12, 1986, p. 27.

Marvel, Bill. "Two small shows are largely entertaining." *The Dallas Times Herald*, March 13, 1986, pp. B3, B5.

Mitchell, Charles Dee. "Nic Nicosia: Dallas Museum of Art." *New Art Examiner*, April 1986, p. 66.

Roth, Nancy. "Engineered Images." *Artpaper*, Summer 1986, p. 24.

Gilsoul, Guy. "Gai-Gai." *Le Vif-L'Express*, June 6, 1986.

J. M. "Nic Nicosia ou l'image-tableau." *La Libre Belgique*, June 6, 1986.

Levin, Kim. "Art: America." *The Village Voice*, July 8, 1986, p. 70.

Kutner, Janet. "Offbeat Views of Texas History." *The Dallas Morning News*, July 8, 1986, pp. E1–E2.

McKenzie, Barbara. "Artist's work is light-hearted look at everyday life." *The Atlanta Journal*, September 19, 1986, p. C2.

Lugo, Mark-Elliott. "Here's a Sampling of Fall's Bounty at Local Galleries." *The Tribune* (San Diego), October 16, 1986, p. E2.

McDonald, Robert. "At The Galleries." *Los Angeles Times*, October 24, 1986, p. J18.

1987

Dorsey, John. "The Confusion of Illusion in Photography." *The Baltimore Sun*, February 10, 1987, p. C1.

Gambrell, Jamey. "Texas: State of the Art." *Art in America*, March 1987, pp. 115–29, 151.

Aletti, Vince. "Photo: Nic Nicosia." *The Village Voice*, March 17, 1987, p. 73.

Freudenheim, Susan. "Suburban Hamlets." *Artforum*, May 1987, pp. 134–40.

Heartney, Eleanor. "Nic Nicosia: Albert Totah." *ARTnews*, May 1987, p. 153.

Stretch, Bonnie Barrett. "Contemporary Photography." *Art and Auction*, May 1987, pp. 140–47.

Mitchell, Charles Dee. "Art: Screwing with reality." *Dallas Observer*, June 11, 1987, pp. 14 and cover.

Schutze, Jim. "Photos set to music spear Dallas' image." *The Dallas Times Herald*, June 22, 1987, p. A7.

Kutner, Janet. "Photo Surrealism: Nic Nicosia's keen eye for the unusual is worth a double take." *The Dallas Morning News*, June 29, 1987, pp. C1–C2.

Kutner, Janet. "That's Life, Museum Receives Nicosia Photo Series." *The Dallas Morning News*, December 5, 1987, pp. C1, C3.

Fey, Shari. "Artist Reaches beyond Photography." *Beaumont Enterprise*, December 6, 1987, p. D1.

Hoy, Anne H. *Fabrications: Staged, Altered, and Appropriated Photographs* (New York: Abbeville Press Publishers, 1987), pp. 38–39.

1988

Barrett, Terry. "Joel-Peter Witkin, Nic Nicosia." *New Art Examiner*, January 1988, p. 65.

Farver, Dana. "Life as Nicosia Knows It." *Ultra Mag.*, February 6, 1988, p. 16.

Adams, Griffin Carolyn. "Rhymes with Ambrosia: Nic Nicosia," *Detour Magazine*, April 1988, p. 21.

Perree, Rob. "De Ontmaskering Van Dynasty." *Kunstbeeld*, April 1988.

Ellens, Mariel. "Texas Anders Bekeken." *Lee Warder Courant*, April 26, 1988, pp. 1–2.

Steenbergen, Renne. "Cliches in Kunst uit Texas." *NRC Handelsblad*, April 27, 1988.

Pouligo, Christian. "Ping-Photo et Pong-Tele." *Photo Magazine*, May 1988.

Johnson, Patricia C. "Photographer Nicosia Gets 'Real,'" *Houston Chronicle*, May 7, 1988, sec. 4, p. 3.

Roegiers, Patrick. "Prises de vues." *Le Monde*, May 20, 1988, p. 27.

Frank, Peter. "Art." *L.A. Weekly*, August 12, 1988.

Knight, Christopher. "Experiencing Life Through Art's Filter." *Los Angeles Herald Examiner*, August 19, 1988, p. 4.

Woodward, Josef. "Along Subversive Detours." *Artweek*, August 20, 1988, p. 1.

S. G. "The Galleries: Wilshire Center." *Los Angeles Times*, August 26, 1988, sec. 6.

Hill, Ed, and Suzanne Bloom. "Nic Nicosia: Texas Gallery." *Artforum*, September 1988, pp. 148–49.

Marvel, Bill. "Remembering the Moment." *The Dallas Morning News*, October 16, 1988, sec. 1, p. 1.

Aletti, Vince. "Choices, Photo: Nic Nicosia." *The Village Voice*, November 15, 1988, p. 44.

1989

Weiley, Susan. "The Darling of the Decade." *ARTnews*, April 1989, pp. 143–50.

Kutner, Janet. "Everything seems . . . Nic Nicosia." *The Dallas Morning News*, April 13, 1989, p. C5.

O'Connor, Colleen. "Nic Nicosia." *The Dallas Morning News*, August 13, 1989, pp. E1–E2, E5.

Muchnic, Suzanne. "A Move to the City for Friends of Photography." *Los Angeles Times*, September 16, 1989, sec. 5, pp. 1, 6.

Kutner, Janet. "A fine pair of artists." *The Dallas Morning News*, September 19, 1989, pp. C1, C7.

Kozloff, Max. "Hapless Figures in an Artificial Storm." *Artforum*, November 1989, pp. 131–36.

Nicosia, Nic. "On Fire: A Project for Artforum by Nic Nicosia." *Artforum*, November 1989, pp. 116–19.

1990

Donohue, Marlena. "The Galleries, Santa Monica: Nic Nicosia." *Los Angeles Times*, January 26, 1990, pp. 20–21.

Aletti, Vince. "Choices, Photo: Nic Nicosia." *The Village Voice*, May 1, 1990, p. 123.

Scanlan, Joe. "Nic Nicosia: Linda Cathcart." *Artscribe*, Summer 1990, p. 84.

Hapgood, Susan. "Nic Nicosia at Facchetti Gallery." *Art in America*, October 1990, pp. 214–15.

1991

Kutner, Janet. "Framed in Satire." *The Dallas Morning News*, March 30, 1991, p. C5.

Artner, Alan G. "Nic Nicosia Explores Modern Romance." *Chicago Tribune*, April 18, 1991, sec. 5, p. 13.

Aletti, Vince. "Choices, Photo: Bettina Rheims/Nic Nicosia." *The Village Voice*, July 23, 1991, pp. 101–102.

"Photography, Nic Nicosia." *The New Yorker*, July 29, 1991, p. 11.

McKenna, Kristine. "Galleries: Slapstick Love and Lust." *Los Angeles Times*, July 30, 1991, p. F5.

Hagen, Charles. "Nic Nicosia: Pace/MacGill." *The New York Times*, August 2, 1991, p. C21.

Frank, Peter. "Art, Pick of the Week." *Los Angeles Weekly*, September 6–12, 1991, p. 13.

Kimmelman, Michael. "Pleasures and Terrors in Home Photographs." *The New York Times*, September 27, 1991, p. B6.

Squiers, Carol. "Domestic Blitz: The Modern Cleans House." *Artforum*, October 1991, pp. 88–91.

Fowler, Jimmy. "Calendar—Nic Nicosia." *Dallas Observer*, November 14, 1991, p. 36.

Kutner, Janet. "A Feast for the Eyes" *The Dallas Morning News*, November 16, 1991, p. C5.

Chadwick, Susan. "MFA Show Contrast . . . Past Present." *The Houston Post*, December 13, 1991, p. E5.

1992

Kalil, Susie. "Looking at Lust." *Houston Press*, February 13, 1992, p. 28.

Chadwick, Susan. "Peeping through the shutter at provocative photo exhibit." *The Houston Post*, February 18, 1992, pp. B1, B8.

Johnson, Patricia C. "Dallas artist Nic Nicosia transforms audience into voyeurs." *Houston Chronicle*, February 22, 1992, p. D8.

Lambrecht, Luk. "Zonder lawaai." *De Morgen*, August 7, 1992, p. 24.

Kutner, Janet. "Art Attack." *The Dallas Morning News*, August 9, 1992, p. C1.

Ruyters, Marc. "Zeven dagen Expo. No man's land." *Knack Weekend*, August 19, 1992, p. 13.

Goldman, Saundra. "Nic Nicosia: Texas." *ARTnews*, September 1992, p. 126.

Eelbode, Erik. "Het theatrale moment." *De Witte Raaf*, November 1992, p. 17.

Lambrecht, Luk. "Aanstekelijke fotografie van Nic Nicosia." *De Morgen*, November 20, 1992, p. 28.

Ruyters, Marc. "Zeven dagen Expo. Wellustig." *Knack Weekend*, November 25, 1992, p. 16.

Kuijken, Ilse. "Nicosia ensceneert blikken van begeerte." *De Standaard*, November 27, 1992, p. 9.

Pültau, Dirk. "Gluren naar foto's en naar jezelf." *De Gentenaar*, November 27, 1992, p. 17.

1993

Eelbode, Erik. "Nic Nicosia: Love + Lust." *Forum International*, March–April 1993, p. 121.

McClure, Richard. "Nic Nicosia: RAAB Gallerie." *What's On* (London), April 14–21, 1993, p. 28.

Schwartzman, Allan. "The America You Can See in Berlin." *Interview*, May 1993, p. 68.

Perrin, Frank. "Nic Nicosia: Blocknotes." *art contemporain*, Summer 1993, p. 62.

"Vivid Art." *Vogue Italia*, August 1993, p. 64.

Kalil, Susie. "The Magic and Mystery of a Family." *Houston Press*, September 16, 1993, pp. 67–69.

Choon, Angela. "Openings." *Art & Antiques*, October 1993, pp. 67–69.

Pagel, David. "Muffled Terror." *Los Angeles Times*, October 12, 1993, p. F8.

Fowler, Jimmy. "Nic Nicosia." *Dallas Observer*, December 23, 1993, p. 26.

Kutner, Janet. "The mysterious world of Nic Nicosia." *The Dallas Morning News*, December 31, 1993, Weekend Guide, p. 42.

1994

Mitchell, Charles Dee. "Family Focus." *The Dallas Morning News*, January 5, 1994, p. A23.

Tager, Alisa. "Nic Nicosia: Linda Cathcart." *ARTnews*, March 1994, p. 143.

Lambrecht, Luk. "Nieuw Werk van de Texaan Nic Nicosia in Gent." *De Morgen*, April 1, 1994, p. 32.

Pültau, Dirk. "Foto's op de naad tussen echt en gespeeld bij Richard Foncke." *De Gentenaar*, April 1, 1994, p. 17.

Braet, Jan. "Over een man die nadenkt." *Knack*, April 6, 1994, pp. 76–80.

Eelbode, Erik. "Een greep uit de kunstactualiteit. Nic Nicosia." *De Witte Raaf*, May 1994, p. 31.

Hagen, Charles. "Nic Nicosia: P•P•O•W Gallery." *The New York Times*, June 24, 1994, p. C17.

Aletti, Vince. "Voice Choices: Nic Nicosia." *The Village Voice*, July 5, 1994, p. 68.

1995

Mitchell, Charles Dee. "Gallery's 'Link' showcases Texas talent." *The Dallas Morning News*, June 18, 1995, p. C6.

Kutner, Janet. "Bold photos, perfect setting." *The Dallas Morning News*, November 17, 1995, pp. C1, C3.

1996

Vuegen, Christine. "Nic Nicosia en de bedrieglijke realiteit van de fotografie." *Kunstbeeld*, March 1996, p. 57.

Eelbode, Erik. "Een fotografische negenakter. Werk van Nic Nicosia in Gentse Foncke Gallery." *De Morgen*, April 10, 1996, p. 17.

Ruyters, Marc. "Expo. In de spots." *Knack Weekend*, April 17, 1996, p. 158.

Kutner, Janet. "Texas Bound." *The Dallas Morning News*, June 27, 1996, p. A33.

Kutner, Janet. "Lone Star Art Stars: Dallas Visual Art Center Showcases State's Top Talent." *The Dallas Morning News*, November 23, 1996, pp. C1, C8.

1997

Camper, Fred. "Nic Nicosia." *Chicago Reader*, March 6, 1997, sec. 1, p. 39.

Artner, Alan G. "Staged photo-fictions." *Chicago Tribune*, March 7, 1997, sec. 7, p. 45.

Kutner, Janet. "A story that is still in developing." *The Dallas Morning News*, April 13, 1997, p. C6.

Akhtar, Suzanne. "Looking at artists in the serial mode." *Fort Worth Star-Telegram*, July 13, 1997, p. G4.

Kutner, Janet. "An eye for the odd." *The Dallas Morning News*, November 4, 1997, pp. 1C–2C.

1998

Lichtenstein, Therese. "Nic Nicosia at P•P•O•W." *Art in America*, February 1998, pp. 102–103.

1999

Commandeur, Ingrid, Jan Hoet, Steven Jacobs, and Els Roelandt. *S.M.A.K. Stedelijk Museum voor Actuele Kunst/Gent. De Verzameling* (Gent and Amsterdam: Ludion, 1999), p. 254.

Catalogue

Publication Coordinator: Lynn M. Herbert
Editor: Polly Koch
Design: Don Quaintance, Public Address Design, Houston
Production Assistant: Elizabeth Frizzell
Typography: Public Address Design; composed in Adobe Minion (text) and Syntax (display)
Color separations/duotones/halftones: Elite Color, East Greenwich, Rhode Island
Printing: Meridian Printing, East Greenwich, Rhode Island

Photography:
All photographs by Nic Nicosia, except those listed below.
Sal Sessa, Dallas: pp. 4–5, figs. 6, 31
Giraudon/Art Resource, NY: fig. 2
George Eastman House: figs. 3, 4
Jeff Wall: fig. 7

fig. 34 (overleaf) Nic Nicosia, *Act 7*, 1994, silver gelatin photograph with oil tint, 49 x 60 inches. Collection Debra Stevens, Dallas.

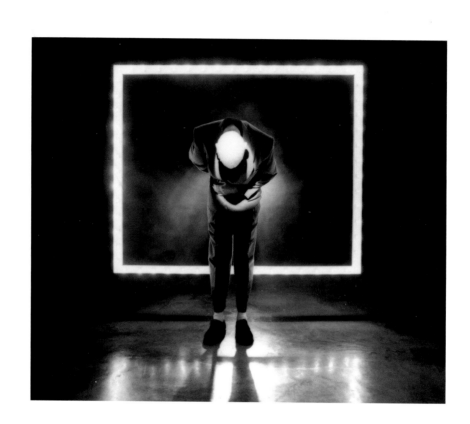